IMAGES
of America

MOUNT DESERT ISLAND

SOMESVILLE, SOUTHWEST HARBOR,
AND NORTHEAST HARBOR

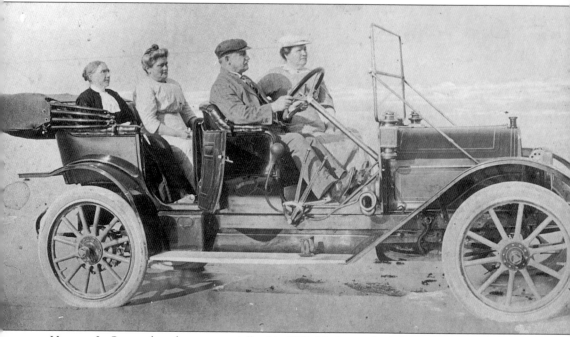

Herman L. Savage loved cars, especially this 1911 Hudson, which he is driving with his sister Cora (in front), his mother behind, and his wife, Wilhelmina (in the white dress) in New Smyrna, Florida, in December 1911. His mother wrote, "Dear Ones, we went over to the beach the other day in our work dresses and here is the result. The surf was fine, it's 71 degrees in the shade." Two years earlier, Herman had showed his opposition to the local law prohibiting automobiles by driving his big automobile straight through Northeast Harbor to his establishment, the Rock End Hotel. (Courtesy of Rick Savage.)

Abbreviations and Sources

Abbreviations:
BHR: Bar Harbor Record
EA: Ellsworth American Newspaper
MHPC: Maine Historic Preservation Commission
MDIHS: Mount Desert Island Historical Society
NEHL: Northeast Harbor Library
SWHL: Southwest Harbor Library

Sources:
Brown, William Adams. *A Teacher and His Times*. New York: Charles Scribner's Sons, 1940.
DeCosta, B.F. *The Hand-Book of Mount Desert*. Boston: A. Williams & Company, 1878.
Drake, Samuel A. *Nooks and Corners of the New England Coast*. New York: Harper & Brothers, 1875.
Favour, Billie. "The Olden Days." Unpublished paper. NEHL.
Martin, Clara Barnes. *Mount Desert on the Coast of Maine*. Portland: Loring, Short & Harmon, 1874.
Sweetser, M.F. *Chisholm's Mount Desert Guide Book*. Portland: Chisholm Brothers, Publishers, 1888.
Varney, George J. *A Gazetteer of the State of Maine*. Boston: B.B. Russell Publishers, 1881.
Vaughan, W.W. *Northeast Harbor Reminiscences*. Boston: White & Horne, 1930.

IMAGES
of America

MOUNT DESERT ISLAND
SOMESVILLE, SOUTHWEST HARBOR, AND NORTHEAST HARBOR

Earle G. Shettleworth Jr. and Lydia B. Vandenbergh

ARCADIA

First printed in 2001.
Repinted in 2001.

Published by Arcadia Publishing,
an imprint of Tempus Publishing, Inc.
2A Cumberland Street
Charleston, SC 29401

Printed in Great Britain.

Library of Congress Catalog Card Number: 2001086550

For all general information contact Arcadia Publishing at:
Telephone 843-853-2070
Fax 843-853-0044
E-Mail sales@arcadiapublishing.com

For customer service and orders:
Toll-Free 1-888-313-2665

Visit us on the internet at http://www.arcadiapublishing.com

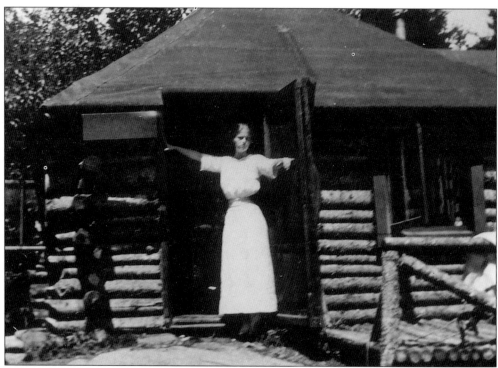

Bart Dyer's rustic mountain hut, the Crags, atop Brown (Norumbega) Mountain, stands in stark contrast to the elegant summer palaces of nearby Bar Harbor. Dyer and his friends, permanent residents of Northeast Harbor, would escape the frantic summer life of their town to their simple retreat. (Courtesy of the Burr family.)

CONTENTS

ACKNOWLEDGMENTS

Developing this pictorial history of Somesville, Southwest Harbor, and Northeast Harbor was similar to creating a jigsaw puzzle, and just as fun. Locating period photographs and correctly identifying their subjects could not have been accomplished without help from the following institutions and families who have preserved these photographs and loaned them to us for inclusion in this book: The Johns Hopkins University's Milton S. Eisenhower Library's Special Collections Department; Great Harbor Collection, Maine Historic Preservation Commission; Mount Desert Island Historical Society; Northeast Harbor Library; Southwest Harbor Library; David and Kathy Burr; James Carroll; Nancy Ho and the Kimball family; Sturgis Haskins; Kay Moore; Nan Lincoln; Connie Seavey; Ralph and Marion Stanley; Lucy Smith; Richard Savage; Ed Wheaton; Stuart Woods; and the Parker family. Credit for the fine reproduction of these photographs goes to Just Black and White Photography in Portland, Maine, and Jeff Thibodeau, who scanned all the SWHL photographs used in this book. With the puzzle pieces assembled, we turned to the following for their historical expertise: Bill Bunting, David and Kathy Burr, Cheryl Chase, the Ellsworth Public Library staff, Jean Fernald, Meredith Hutchins, Mary Jones, Daniel Kimball, Chuck Liebow, Richard Lunt, the Northeast Harbor Literary Club, Bob Pyle and the NEHL staff, Janet Patton, Jaylene Roths, Sydney Rockefeller, Dan Smith, James Stimpert and Margaret Burri, the late Bob Suminsby, Kathy Suminsby, Raymond Strout, Paul Stubing, and Deborah Thompson. We are especially appreciative to island historians Rick Savage, Juanita Sprague, Steve Haynes, and Ralph Stanley for contributing their vast knowledge to this project by writing seven captions. We owe our thanks to Sharon Morang for typing many of the captions. With the text completed, we turned to my parents, Herbert and Taffy Bodman, my favorite logophiles, to lend a hand polishing the manuscript. Many thanks as well to our editor at Arcadia Publishing, Peter Turco, for his constant encouragement and flexibility. Finally, my deepest appreciation to my family, David, Christina, and Alex Vandenbergh, whose patience, support, and humor carried me through this project with a smile.

This book is dedicated to Bob Pyle of Northeast Harbor,
Ralph Stanley of Southwest Harbor, and Jaylene Roths of
Somesville, three residents who have demonstrated their commitment to
preserving Mount Desert Island's heritage.

INTRODUCTION

When Abraham Somes, a fisherman from Gloucester, Massachusetts, first saw Mount Desert Island, it was probably the island's bold granite mountains, rugged coastline, and Norwegian-like fjord that first caught his attention. Although these attributes attracted romantic tourists to its shores a century later, Somes chose the island as his new home for its plentiful resources. He saw the island's dense forests as good logging and building materials, swift steams for water and power, natural salt marshes as fodder for livestock, deep coves as safe ports for coasting vessels, and the seven-mile fjord as a protective buffer for his home. Protection was of prime importance to this pioneer. By the time he moved to the island in 1761, the British had won their war with the French and Indians, but Somes still viewed the wilderness as an area fraught with dangers. Despite this fear, the island's first families—Abraham and Hannah Somes and James and Rachel Richardson—settled at the head of Somes Sound, peacefully coexisting with the Penobscot and Passamaquoddy tribes of the Abenaki Indians, who for many centuries had ventured each summer to Mount Desert Island to build up their winter stores of smoked fish, berries, and small game.

In 1789, the island was incorporated as the town of Mount Desert, then a part of Massachusetts. A short time later, the island was divided into two townships: Eden (later called Bar Harbor), lying roughly to the northeast of Somes Sound, and the remainder belonging to Mount Desert Township. In 1848, (28 years after Maine became a state), the town of Tremont separated from Mount Desert.

In the first half of the 19th century, the island's population tripled from fewer than 1,000 to 3,329 people. Scattered homesteads formed a few small villages west of Eden, including Somesville, Southwest Harbor, Northeast Harbor, Bass Harbor (then known as McKinley), and Seal Harbor (Long Pond). Logging, fishing, shipbuilding, and coastal trading were the dominant occupations, with the hub of commerce located in Somesville (also known simply as Mount Desert). These were self-sufficient homesteaders, living off what the land and sea provided and inhabiting Cape-style homes that reflected their modest means.

By the outbreak of the Civil War, Somesville was a bustling village with several mills, a few merchants, shipbuilders, a shoe factory, and a woolen mill. This prosperity attracted new professionals to the area: storekeepers, blacksmiths, carpenters, and even an undertaker. Southwest Harbor experienced a similar expansion in the 1850s after the establishment of the William Underwood & Company lobster factory, which was followed by fishing industries, merchants, and manufacturers. Northeast Harbor was home to a few fishermen and mariners. The impact of the Civil War on the island was typical of many small towns. Men who had not paid for substitutes went off to war, leaving wives to hold the full burden of tending children, farms, and any industrial operations. The area, especially Somesville and Northeast Harbor, suffered greatly from the human loss and economic decline of the Civil War and did not recover until the 1880s.

In the mid-19th century, as the Industrial Revolution took hold in the northern states, a reactionary movement called transcendentalism was growing—advocated by writers Ralph Waldo Emerson and Henry David Thoreau. Viewing the encroachment of industrialization as a threat to the nation and the human soul, Emerson suggested nature as the salvation: "These enchantments [walks in nature] are medicinal, they sober and heal us. . . . We nestle in nature, and draw our living as parasites from her roots and grains, and we receive glances from heavenly bodies, which call us to solitude and foretell the remotest future." The art world also shared this view of nature. Acclaimed landscape artist Thomas Cole, founder of the Hudson River School of Painting, visited Mount Desert Island in the 1840s. His romantic paintings of the region

influenced other artists to visit the island, including his disciple, Frederick Church. Even doctors were extolling the benefits of outdoor life. Along with these trends was a blossoming middle class that was now able to afford vacations. Their search for the perfect spot was aided by an increasing number of writers describing scenic locations in magazines, newspapers, and guidebooks, as the following sketch by Eliot Shepard of an excursion up Somes Sound exemplifies:

> The Orientalist's dream of sailing 1,000 yards under rainbows was nothing to it. The water ahead was one immense amethyst, on our port side one immense sapphire; on our starboard side one immense emerald; our wake followed us with opals: the sunlit Atlantic lay south of us like a miraculous topaz; the palisades on the westerly side of Somes Sound reproduced the granite walls in the translucent flood; the sun flung out his shining beams like a golden aureole to our ship and we were at the centre of ecstasy and the climax of wonderland. (*Pemaquid Messenger*, September 14, 1893.)

With such rambling Victorian prose, who could resist the shores of Mount Desert?

Deacon Henry H. Clark, an enterprising Southwest Harbor resident, facilitated tourism and new industries by building a steamboat wharf on Southwest Harbor's northern shore in the 1850s and by opening the Island House Inn as the area's first hotel. Soon the Portland steamers began regular landings to Southwest Harbor. Several other islanders began to take rusticators, as these visitors were called locally, into their homes, supplementing their incomes from the traditional occupations of lumbering, fishing, and shipbuilding.

Cleveland Amory, a Bar Harbor cottager and author of *The Last Resorts*, theorized that a resort develops in a predictable pattern. Artists and writers first discover the watering places and spread the word through their canvases and articles. Academics follow, at first boarding with the islanders and then establishing themselves permanently by building cottages. The last group to settle, the aristocracy, then drives away the boarders.

The resorts situated to the west of Bar Harbor followed this pattern except for the last stage. As predicted, educated men—academics and theologians—frequented the boardinghouses and modest hotels in Somesville, Southwest Harbor, and Northeast Harbor during the 1870s. These men had the good fortune to have their summers free and their modest faculty salaries augmented by family inheritance. Harvard Pres. George Eliot (whose father initiated a summer colony in Nahant along the Beverly, Massachusetts shore) explained his selection of Northeast Harbor in a letter to Johns Hopkins University Pres. Daniel C. Gilman: "The Beverly shore is the best thing there is in this country for the businessman who must go to town everyday. You and I are freer in summer and can consequently do much better than to dwell on that highly sophisticated coast." (Letter from Eliot to Gilman, October 20, 1885.) The island's natural beauty, cool summer climate, sailing and fishing facilities, and wild rocky hills were obvious attractions for these renaissance men, but there were other appealing factors as well. William C. Doane, bishop of Albany, admired the sturdy New England folk. "Many of them," he observed, "had lived lives of real adventure on the sea in long and perilous voyages. The competency on which they lived simple and unspoiled lives, of home comfort and neighborly companionship, was gained by honest and careful frugality." (George Street, page 288.) This compassionate feeling toward the natives was echoed by Samuel Eliot Morison, who noted that the pioneer isolation made human kindness a valued characteristic.

Early cottagers followed the simple living patterns of the islanders. Many took their meals at the nearby hotels. This early cottage life was fondly remembered by Jarvis Cromwell: "In 1900, the residents and summer visitors lived pretty much alike. There was no telephone, no electricity, no automobiles, only a few horses for transportation. Every permanent resident had a little garden and most everybody spent a considerable part of the day fishing for flounder cod and perch. . . . As a result of these conditions, there was very little difference in the way everybody on the island lived. The local people were a splendid independent lot and summer folk had to qualify in one way or another to be generally accepted as friends." (Jarvis Cromwell

paper, NEHL.) Harvard Pres. Charles Eliot's plain living set a standard for other visitors. When a newcomer at Augustus Savage's Asticou Inn complained about cold vegetables served at dinner, "she was told kindly but firmly, 'What is good enough for President Eliot is good enough for anyone." (William Adams Brown, page 145.) Bishop Doane recalled that "there were certain difficulties and disadvantages in the remoteness of the place, but on the whole the life of constant contact with nature, untouched and unspoiled, in this marvelous atmosphere, and the relations established with the people who lived here, more than compensated for whatever privation one had to bear." (George Street, page 289.)

As the 1870s and early 1880s were defined as the boardinghouse era, the 1890s saw the blossoming of three resorts, each attracting a distinct clientele. Somesville, once the island's core of industrial and commercial activity, had quieted by the turn of the century with five stores, a post office, a telephone office, a sawmill, two small inns, and two boardinghouses. The famous Mount Desert House, the island's first tavern had closed, though accommodations could be found at George B. Somes' Inn and its cottages and at the Central House, Mrs. William Fennelly's Inn popular for its chicken dinners. Boarders were also welcome at the Atherton's home and John Jabob Somes' cottage. A few private cottages were scattered across the village. This type of quiet, unobtrusive resort fit the character of the village: tranquil and quite content with having a few modest inns and boardinghouses.

Down the road, Southwest Harbor had developed a split personality by the 1890s. Its thriving industries, based primarily on fishing and ice manufacturing, coexisted with a summer resort comprised primarily of several large hotels. The cottages owned in the 1880s were few in number and mostly owned by academics. The two exceptions to this modest style were two stately turreted summer homes built by Philadelphia businessman Robert Kaighn and his brother-in-law Samuel C. Cooper. Southwest Harbor's character was aptly described in Chisolm's 1888 guidebook as "the paradise of the unconventional, where simplicity in dress is the rule, and flannels and cambrics form the customary attire. The life is largely outdoor, and every facility is afforded for buckboard rides among the contiguous mountains and for rowing and sailing over the surrounding waters. The hotels are merely larger boarding houses, whose rates remain at figures which invite long sojourns and allow for free outlays for general amusements." Southwest Harbor's cottage life would blossom after World War I, though it would still maintain a low-key, democratic spirit alongside an active hotel clientele.

Northeast Harbor, across Somes Sound from Southwest, would become a sophisticated summer colony led by a triumvirate of Charles Eliot, Bishop Doane, and Daniel Coit Gilman, who emphasized family and religion. Unlike Southwest, this village lacked a concentration of industry, making it all the more perfect for islanders Loren Kimball and Herman Savage, skilled hotel proprietors, to promote the village as a perfect resort. The triumvirate convinced many of their family and friends to join their colony, including such prominent businessmen as Erastus Corning and Samuel D. Sargeant, although the secret could not be kept for long. As the Bar Harbor Record reported, "the bishop and his friends wanted to keep NEH exclusively to themselves, but this was not possible. People began to hear of the beauties of the place and the very exclusive circle who held sway there and they wanted to be in it so after a few years of undisturbed quiet, the bishop and his friends were obliged to yield gracefully to the encroachment of the summer civilization, and now there is not a more popular place on the Maine coast, or hotels anywhere that are keeping their own like the Kimball House, Rock End, Savages, etc." (BHR, May 17, 1894.)

At the beginning of the 20th century, the initial easy summer life began to increase in structure and formality. Elaborate dinners and weekly hops at the Rock End Hotel and the Kimball House dominated the evening activities. Many bemoaned the shift from simple frame cottages to "stylish Queen Anne abodes, trimly cut lawns, and the regimented social life of breakfast at noon, formal dinners at 7, guests and receptions. The picturesque knickerbockers give way to the formal dress coat and the destroying angel of fashion broods over the mountain peaks of my beloved island." (Mount Desert Herald, August 20, 1881.)

This change reflected the social patterns of the times, separating the cottagers from the permanent residents. The organization of the swimming pool in 1898 further divided these groups. The Northeast Harbor summer community's ability to adapt to changing lifestyles and economic forces in the years to come was due to the continuity of the summer families, the relatively moderate size of their cottages, and the leadership provided by the summer and islander communities.

New jobs associated with the summer colony brought prosperity to the permanent residents, building a stable middle-class community. With rising incomes of the islanders and support from the summer colony, each of the three communities had thriving libraries, schools, and churches. Some of the permanent residents were able to become vacationers themselves, spending the winter season in Florida and Colorado Springs.

What had not changed between the mid-19th century and the early 20th century was the season of employment. In the early days, men had patched together their income from such sources as lumbering, coasting, and fishing. It was rare for a person to have a single job. While there were a few women who worked outside the home, most tended to the house, the farm, and the children. After 1900, prosperity and tourism created new employment possibilities for both men and women, although many of these jobs remained seasonal. From early spring to mid-autumn, islanders' lives revolved around the summer colony at a frantic pace. Roads were mended. Gardeners tended new beds. Caretakers spruced up the cottages, and carpenters mended aging buildings. Storekeepers opened summer shops. Fishermen cleaned up their boats, gave them a fresh coat of paint, and readied them for excursions.

Women also played an important role in this expanded economy from storekeepers, milliners, and caretakers to real estate agents, librarians, and telephone operators. Since many permanent residents continued to rent their homes to families for the summer, moving day each May and September was as significant as any national holiday. "It entailed completely clearing a family of six out of one house and into another twice a year," as Northeast Harbor resident Billy Favour explained. "This was no small task, but Mother got it down to a system. Two professional cleaners Florence Reed and Suzie Norwood worked with Mother to get the houses spic and span Rugs were beaten or swept, clean chintz draperies were hung in front . . . meanwhile the men were taking off storm windows, painting blinds and varnishing floors. And the curtains. All the windows in all 3 houses had starched, white, ruffled, organdy curtains, and Grandma did them for weeks and weeks, beginning in early March."

Islanders' homes also reflected growing affluence. Some merely added porches to their classic Cape-style homesteads, reflecting increased leisure time and the benefits of fresh air, while others built new homes in the Victorian Shingle style.

When the hectic summer season ended, the permanent residents resumed their winter schedules. Autumn brought a sigh of relief, as reflected in this islander's statement: "The season of work is over and we can stop now and take a breath and look about us, remembering our friends and neighbors. We can take quiet comfort in their society, which has been unknown through the long summer months of rush and bustle." (EA, September 14, 1903.)

By World War I, all three communities had experienced social and economic shifts that set the stage for the next century. Somesville became a tranquil resort with one hotel, a dozen cottages, and a few stores. The former boardinghouses of Babson, Atherton, and William Fennelly's Central House closed when their proprietors died, leaving only the Somes House Inn for hotel accommodations. Southwest Harbor's thriving fishing and boatbuilding enterprises coexisted with a low-key summer resort that grew in number through the 1920s. By 1910, Northeast Harbor could boast 100 summer cottages, 7 summer hotels, and the largest island village west of Bar Harbor.

This pictorial volume chronicles the story of these communities between the Civil War and World War I. As is evident, diversity has always been Mount Desert Island's greatest strength. Its villages, each with its own personality and clientele, are no exception, as Clara Barnes Martin understood when she described the island as offering "infinite riches in a little room."

One

SOMESVILLE

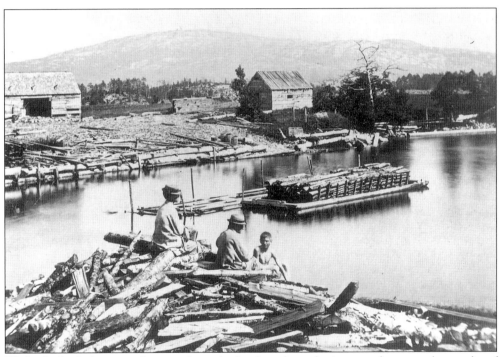

With thick dark green forests of sturdy hardwoods and pines, and an ample supply of waterpower, it was not difficult for Abraham Somes to comply with Massachusetts Gov. Francis Bernard's request of Somes to settle on Mount Desert Island and build mills. Somes built a shingle mill and gristmill flanking the Somesville brook. He also built this sawmill on the cusp of Somes Cove, to which the brook flowed—a location that enabled lumbermen to float the trees to the sawmill for cutting. This threesome has a perfect view of the mill, inherited by grandson John Somes Jr., with Sargent's Mountain looming behind them. By the time this 1870s photograph was taken, aggressive felling to produce lumber for boxes and furniture opened up the landscape, producing meadows in the lowlands and splendid vistas from the mountains. (Courtesy of MHPC.)

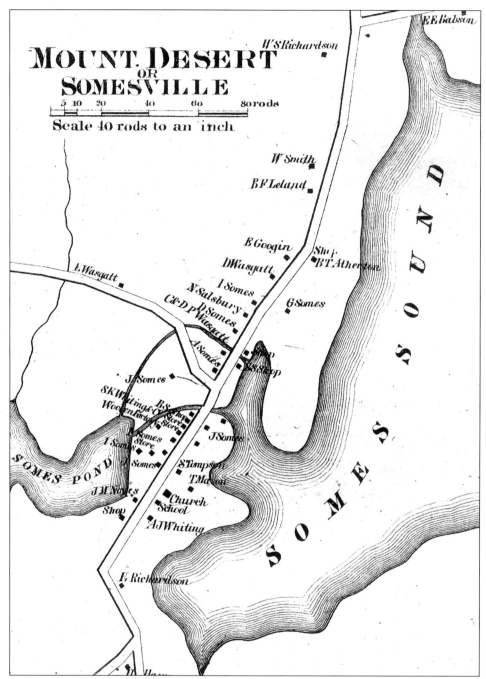

This 1860s map of Somesville illustrates that much had changed in the century since Abraham Somes first settled in the area. The various types of lumbermills he and his sons developed over the century still remained, as did the thriving carding mill, gristmill, shipyards, shoe shop, blacksmith shop, several stores, and the famous Mount Desert House. This bustling village, the hub of commerce on the island by mid-century, had attracted entrepreneurs like Andrew J. Whiting and John Noyes, expanding the number of families calling Somesville their home to 12. (Courtesy of MHPC.)

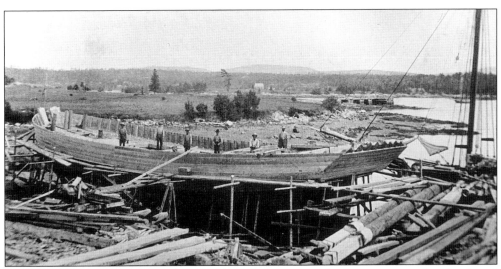

Shipbuilders are taking a break from building this two-masted schooner, a vessel with a broad beam probably built to sail the West Indies trade route. The schooner *Flora Grindle* lies at the right. Ships built on the island served to transport the locally produced lumber, salted fish, barrels, ice, bricks and stones to market, and to import all necessary supplies as well. In Somes Harbor, five shipyards nestled around its shores. Each decade between 1830 and 1850, more than 50 boats were built in the Mount Desert Island area. (Courtesy of MDIHS.)

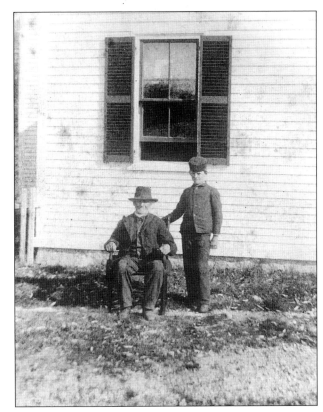

In the early 1880s, John Somes Jr. poses with his grandson John Allen Somes. The elder, a keen businessman, took after his father, John Sr., running the village's first store, operating the lumber and allied mills, and building ships. By 1840, these industries had made this family branch the wealthiest family in Mount Desert township. John Allen continued to prosper in contracting and building until his death in 1930. Civic pride ran in the family. John Somes Sr. served in the state legislature from 1815 to 1818 and John Jr. became the Mount Desert township's first postmaster, holding the position for 40 years. (Courtesy of MHPC.)

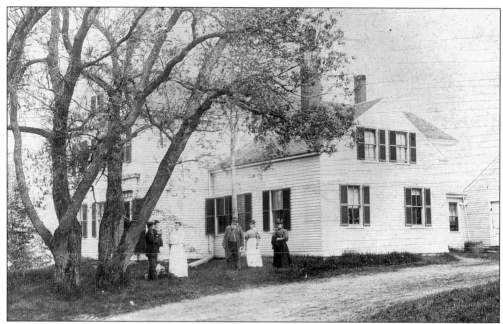

Around 1900, white-bearded John W. Somes, known as John Bill, stands beside his sister Sara and niece Kate Heath Pray while his son's family—John Allen (Allie), Mark, and Ada—are shaded by the arching tree outside the family home in Somesville. J.W. Somes was as patriotic as his forbears, serving in the state legislature, the town government, and helping to establish the Trenton bridge. "The very name of John Bill Somes was a household word and the kindly old gentleman is as much a familiar part of the Mount Desert town as any of the natural landscapes." (Northeast Harbor Library papers; photograph courtesy of MDIHS.)

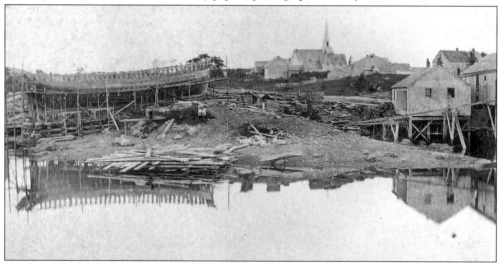

By the time this photograph of Somes Cove was taken in the 1870s, shipbuilding was waning, even in Somesville, "where at one time it made things quite lively," as H.M. Eaton described in 1889. Replacing that demand for lumber was real estate development, first in Southwest Harbor, then followed by Northeast Harbor and Seal Harbor. The newly expanded local ice industry, requiring icehouses and sawdust, also contributed to prosperous lumbermills. (Courtesy of MHPC.)

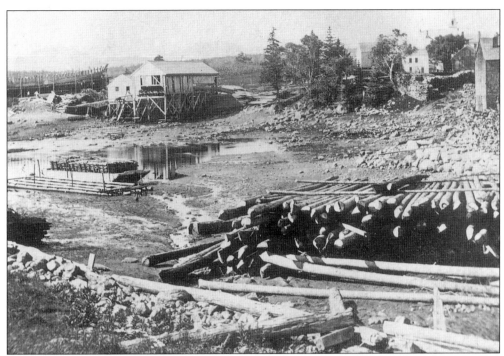

The outgoing tide has drained Somes Cove of water, leaving the planked boat and its neighboring scow, loaded with lumber, grounded. Although one might think the logs at right are piled for launching vessels, they are probably destined to be used to build a wharf. The thin logs on top would have held long spikes, keeping the entire pile from collapsing. At this early date, there was no wharf adjacent to Whiting's warehouse, at right. Freight, such as these logs, would have been loaded on scows and carried out to a waiting coaster. (Courtesy of MHPC.)

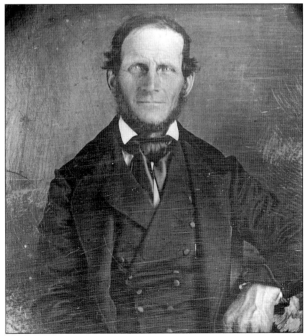

Abraham Somes III, third son of John Somes Jr., followed his father's career as a shipwright and traveled to the West Indies frequently. On his returns, he brought goods to his father's store and supplies such as indigo dye to his cousin's woolen mill. Due to unsteady weather, travel to the West Indies was the most arduous coasting assignment, although it introduced exotic cultures to rural Maine. Many mariners turned to trading along the eastern seaboard, as it ensured a steadier income than foreign trips and allowed the crew more time at home. (Courtesy of MDIHS.)

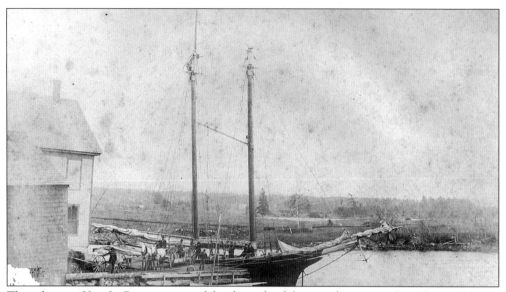

The schooner *Kate L. Pray* was named for the wife of the vessel's master, Capt. Lester Pray, as was a common practice in those days. The ship was built in 1886 by master builder and primary owner Elihu T. Hamor at Hull's Cove in Eden, the neighboring town. Tragedy struck the vessel while loaded with stone in October 1891. Capt. John Pray, brother of Lester, fell off the bow sprit and drowned while taking in the jib during rough weather. Almost every family on the island had lost a member at sea at one time or another, and they were not always men. (Caption by Ralph Stanley; photograph courtesy of MDIHS.)

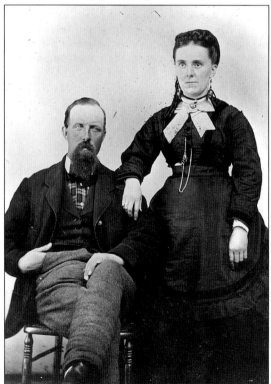

Their solemn expressions mask the kindly manner and genial spirits that describe Thaddeus Somes and his wife, Emilie Meynell Somes. His was a familiar face in both Mount Desert and Southwest Harbor from his service as a selectman and deputy customs agent. His leadership and generosity are epitomized in the Memorial Bridge, dedicated in his memory; the bridge spans the brook near his home. (Courtesy of MDIHS.)

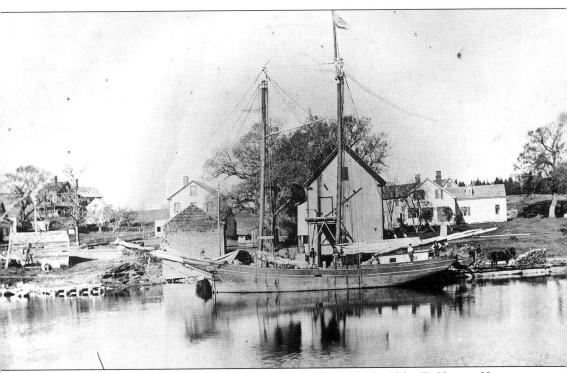

The schooner *E.T. Hamor*, shown at Fernald's wharf, was owned by Elihu T. Hamor. Hamor also built the ship at Hull's Cove in 1889. Like the *Kate L. Pray*, this vessel was typical of the small two-masted coasting schooners that sailed to ports along the East Coast carrying locally produced items. Returning from these ports, the schooners' crews conveniently supplied the general stores in the small, out-of-the-way coves and islands on the Maine coast with merchandise that could not easily be delivered by other means. They also brought bulk shipments such as coal for local industry and salt, essential for the fisheries. Every little cove had a wharf where a vessel could safely ground out to be unloaded. The mud near the wharf would be kept level and clear of rocks to make a safe bed to support the weight of the vessel and cargo while unloading. (Caption by Ralph Stanley; photograph courtesy of MDIHS.)

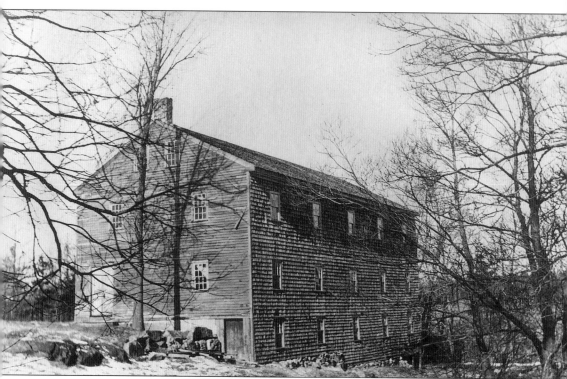

This mid-19th-century water-powered woolen mill stood on the south side of Cemetery Road. Operated by Abraham Somes Jr. and his son Isaac, the mill converted wool into yarn for spinning cloth. As Eben Hamor recalled, "almost every family kept sheep in the middle 1880s, and it was a saving of time and effort to be able to have carding, fulling, and dying at an established factory." In the winter months, the mill sometimes doubled as a public hall. This was where, in 1847, a group of Penobscot Native Americans from Old Town performed native dances for local residents. (Courtesy of MDIHS.)

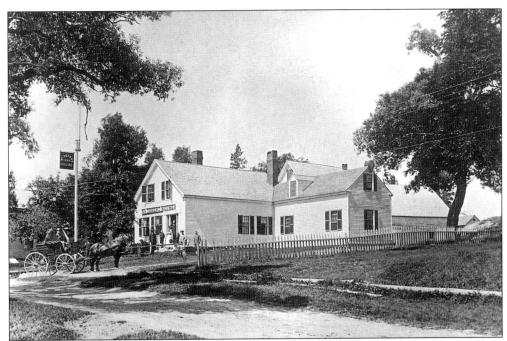

When M.F. Sweetser wrote *Chisholm's Mount Desert Guide Book* in 1888, he described the Mount Desert House as "the first hotel on the island, opened 50 years ago and celebrated for its homely good cheer and its quaint rooms and furniture." Established by Daniel Somes and continued by his son Daniel Somes Jr., this popular hostelry served as the stop for the mail stage and accommodated early summer visitors, including the Hudson River School artists Thomas Cole and Frederick Church. After many decades as an inn, the Mount Desert House became the summer home of Bishop William T. Manning of New York. (Courtesy of MDIHS.)

Daniel Somes Jr. (1803–1882), called "Old Uncle Daniel" by some, owned the Somesville tannery and nearby shoe factory, businesses that his father had established. His brother Lewis operated the cobbler shop while Daniel and his wife, Sally Trask Somes, hosted rusticators at their inn. Much of the time, Daniel was occupied with official business as deputy customs officer for the island. (His father had held the first customs officer position on the island.) One suspects that as the hostelry business expanded, the pungent tannery close by was closed to preserve the pleasant atmosphere for excursionists. (Courtesy of MDIHS.)

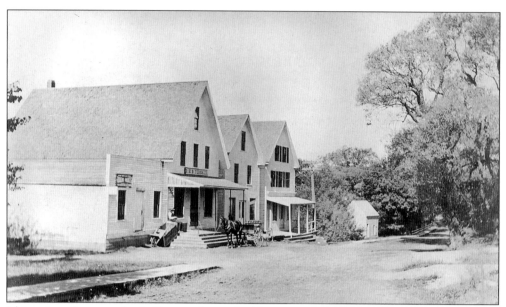

This row of two-and-a-half-story frame buildings comprised the commercial center of Somesville for much of its history. Dating from 1856, the large building at the left was serving as R.H.B. Fernald's store when this late-19th-century photograph was taken. Known as "the yellow store," the middle building housed the post office and a school. Various shops, including milliners, used the first floor of the third building. The second floor contained a hall for Masons and other fraternal groups. Beyond this commercial row stood the selectman's building, a modest one-story structure that had also been the site of a shoemaker's shop and a school. This building is now on the grounds of the Mount Desert Island Historical Society. (Courtesy of MDIHS.)

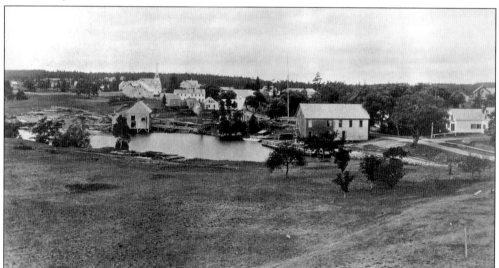

This pre-1893 view of Somes Cove shows the Mount Desert House at the far right. The Fernald Brothers' store is to the left, and a short distance further to left is the elder Fernald's undertaker's shop, almost hidden by the trees. In 1893, this building burned to the ground along with its contents, including 60 caskets, $300 in cash, and $1,200 in securities. In 1894, a library was built in its place. (Courtesy of MDIHS.)

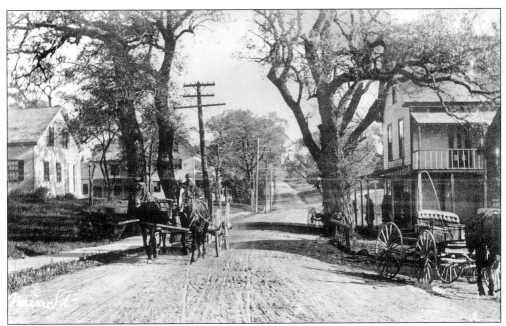

Fernald's store, right, had its modest beginnings as Andrew J. Whiting's warehouse. The building had a public hall on the second floor. In 1887, Whiting sold the warehouse to brothers A.C., Walter, and R.H. Brigham Fernald, who converted the lower part to a store. The upper hall, where meetings and dramatic performances had been held for years, was transformed into a funeral parlor. In the late 1870s, their father, A.C. Fernald, had established his undertaker business in Somesville, a business that to this day remains in the family. (Courtesy of MDIHS.)

By the time Andrew Jackson Whiting died in 1896, the energetic entrepreneur had established a variety of businesses during his 40 years in Somesville. Well known was his store begun with his brother S.K. Whiting, later purchased by R.H. Fernald, which supplied vessels with merchandise. A.J. Whiting invested in ships, built houses for rent, and joined with Obidiah Allen in establishing their Somes Sound quarry. As Whiting prospered, he and his wife, Hittie, gave generously to support local projects, including the decorative wrought-iron gate at the entrance to Brookside Cemetery. (Courtesy of MDIHS.)

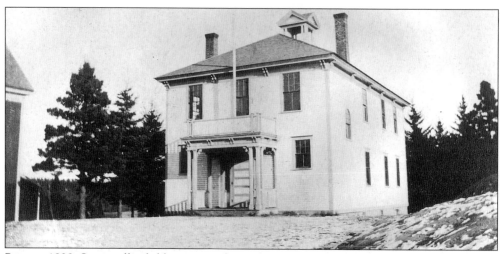

Prior to 1898, Somesville children were educated in one-room schoolhouses or in the meeting halls of commercial buildings. That year, the town built this consolidated school at the north end of the village. Primary students attended classes on the first floor, and the upper grades used the second floor, including high school students from 1903 to 1943. The building was enlarged in 1929 to better accommodate the high school, which moved to Northeast Harbor in 1943. In the 1980s, the old school found new life by being converted into residential condominiums. (Courtesy of MDIHS.)

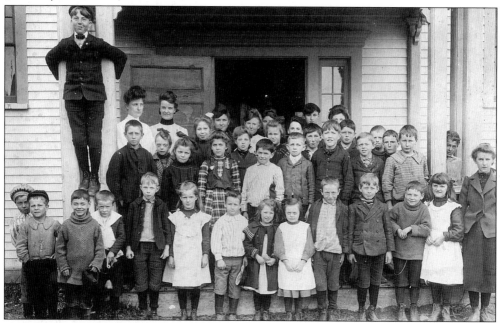

The Common School pupils in Somesville ranged in age from the little tykes in front to the older children clustered by the doorway. Three eight-week sessions of common school were offered annually, but that did not complete their studying. Private day and evening schools were frequently held, specializing in penmanship, grammar, and geography. Although elementary school teaching was poorly paid, especially for women, Somesville had its share of educators. In 1895, the village could boast seven schoolteachers within less than one-half mile who were teaching in the township. (Courtesy of MDIHS.)

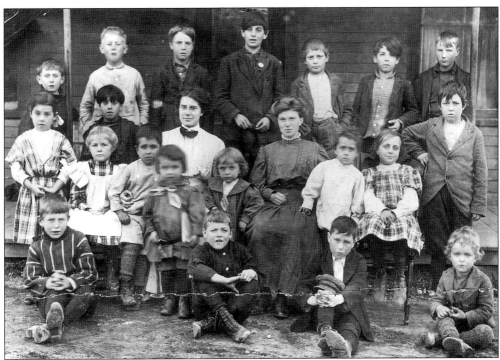

In 1892, with three quarrying firms operating on the eastern shore of Somes Sound, that community's residents approved $900 to erect a substantial new schoolhouse on land located between Wasgatt's blacksmith shop and E.M. Higgin's boardinghouse. Two local societies, the Ladies Sewing Society and the Busy Bee Society, raised money to purchase the bell to hang in the belfry, a flag, and other furnishings. By 1909, these children of the Gonzales, Higgins, Brown, Carter, Havey, and Grindle families had settled in, with teacher Emily Phillips at the helm. (Courtesy of MDIHS.)

For nearly a century and a half, the Somesville Union Meeting House has been a landmark in the community. Built in 1852, this classic Greek Revival church is believed to have been designed by Benjamin S. Deane of Bangor, the leading architect in eastern Maine in the middle of the 19th century. Using plate 59 of Asher Benjamin's 1839 *The Builder's Guide*, Deane planned this and similar meetinghouses in Orland, Stetson, and East Bangor. The land for the Somesville church was given by John Somes Jr., and John M. Noyes served as the contractor. Erected at a cost of $2,500, the building was debt-free upon completion thanks to the sale of pews, gifts, and donated labor. (Courtesy of MHPC.)

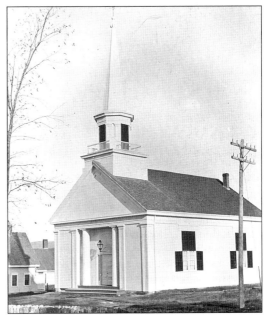

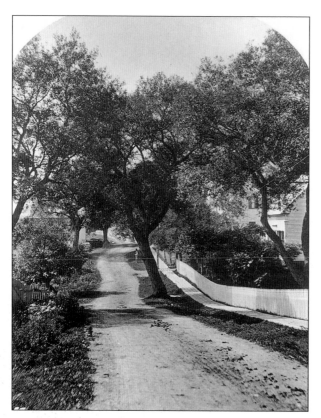

During the 1880s, the Bar Harbor photographer Bryant Bradley captured this handsome view of Somesville's shaded main street, a narrow dirt road with a board sidewalk and white picket fences. This was the scene that M.F. Sweetser described in 1888 in *Chisholm's Mount Desert Guide Book*: "Somesville is a pretty white village of 500 inhabitants, nestling around a snug cove at head of Somes Sound. The neat white houses, with green blinds, under arches of foliage, give it a comfortable appearance of an ancient village of New England." One such dwelling, the Lewis Somes House, can be glimpsed through the trees at the right. (Courtesy of MHPC.)

Called the Dean of Hancock County's medical profession, Dr. Robert L. Grindle "ministered not alone as physician, but as friend and guide and counselor to three generations." (BHT.) Grindle was not unlike his predecessor, the island's first physician, Dr. Kendell Kittridge, who settled at the head of Somes Sound in 1791 and practiced medicine for 60 years. Both were leaders in the Somesville Congregational Church and practiced farming on the side. Known for his oratory talents, Grindle served in both houses of the state legislature. After his death, Grindle's son Jay carried on as a physician for many years. (Courtesy of MDIHS.)

24

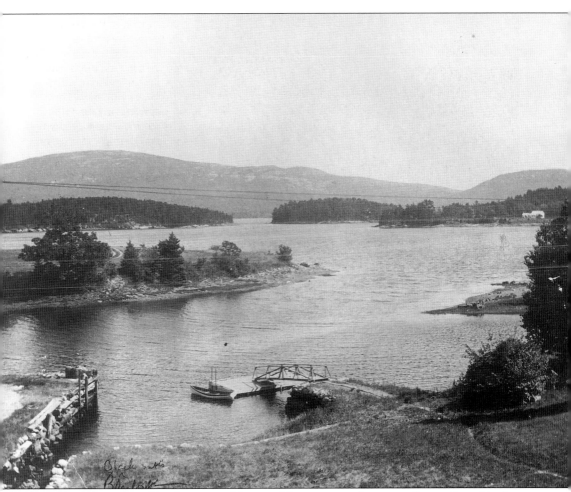

The tranquility suggested by this view of Sargent Mountain watching over Somes Sound is the magnet that attracted summer sojourners to this placid hamlet. As the industries that once made Somesville such a lively place year-round disappeared, several islanders began expanding their homes, catering to summer visitors. In 1885, Benjamin and Emily Atherton, both teachers in area schools, added a wing to their house and welcomed boarders. Over time, dinner parties would become their specialty. As early as 1886, Mrs. William Fennelly, owner of the Central House along Somesville's Main Street, specialized in chicken and muffin dinners and asked that her patrons order by telephone. The *Bar Harbor Record* suggested to its readers in 1893 that "not taking a trip to Somesville during a sojourn to Mount Desert is to miss one of the most picturesque parts of the island. Reaching Somesville at 12:30 pm, there is ample opportunity for an excellent dinner at the Central House which is just a pleasant walk from the landing and return at 4 pm." The foundation for Somesville as a quiet resort had been laid. (Courtesy of MDIHS.)

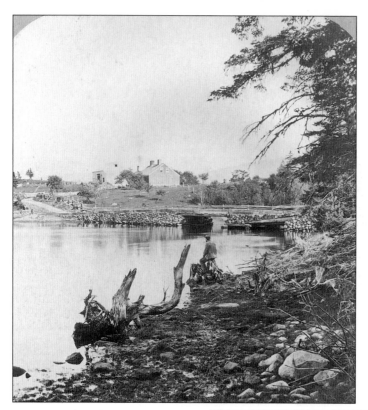

A native of Gloucester, Massachusetts, Capt. Eben Babson came to Somesville in the early 1800s and married Judith Somes in 1815. They resided near the village in this large Cape, which stood on the rise beyond the stone bridge named for Babson. In 1840, Eben, like his fellow mariners, was also a subsistence farmer, with 100 acres of land, 3 cows, 2 oxen, and 14 sheep. (Courtesy of MHPC.)

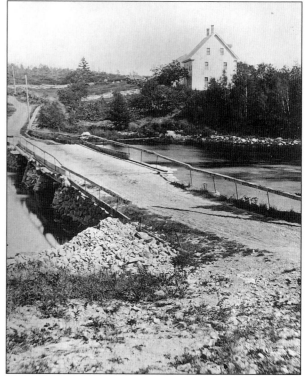

In this photograph taken by Bryant Bradley in the 1880s, the rude stone bridge has not changed, but Eben Babson's Cape has been enlarged into a sizable two-and-a-half-story house. The captain's son expanded the family homestead in the 1870s to take in summer visitors. Newspaper accounts of the 1880s indicate that the Babson House was filled with guests. Ministers and their families were especially drawn to its doors. (Courtesy of MDIHS.)

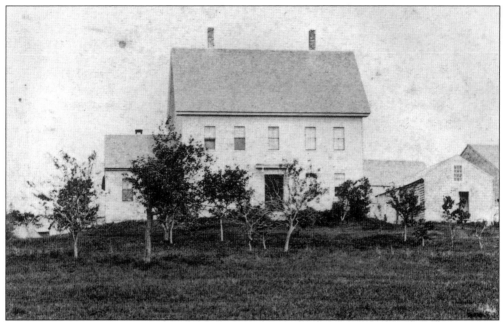

The Somes House, a popular summer hotel, had its origins in this two-and-a-half-story dwelling that incorporated parts of Abraham Somes' 18th-century homestead. Located in Somes Meadow, the hostelry enjoyed a commanding view of the harbor. In response to the community's growth as a summer destination, descendants of Mount Desert's first permanent settler expanded their ancestral Cape-style house to take in boarders. (Courtesy of MDIHS.)

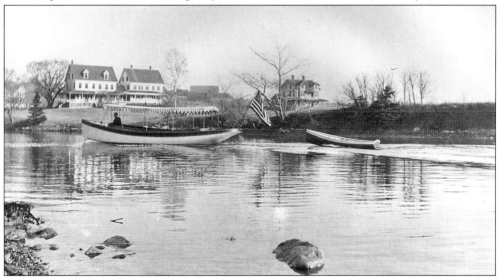

In this turn-of-the-century view, a naptha launch glides by the Somes House. When George A. Somes inherited the property, he expanded the family inn by constructing two large additions, one attached at the left and the other freestanding to the right, giving the hotel a capacity of 150 guests. Noted visitors included Louis Comfort Tiffany, Alfred Vanderbilt, Joseph Pulitzer, J.P. Morgan, Pres. William Howard Taft, and Mary Cassatt. Known for its chicken and lobster dinners, the Somes House operated into the 1950s with rates of $5 to $10 a day. (Courtesy of NEHL.)

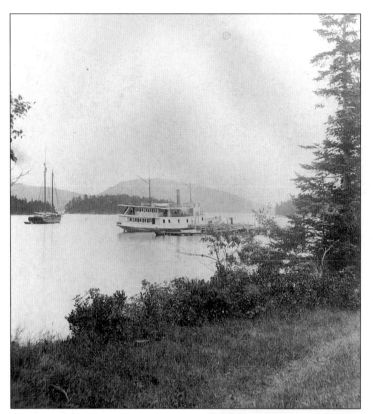

In the 1880s and 1890s, Somesville was a designated stop in the summer for a variety of small steamers, such as the elegant *Cimbria,* shown here. In the winter, however, freight had to be carried by coasters, such as the vessel at left, to the village storekeepers. A frozen Somes Sound would often block these sailing vessels, forcing the crew to unload the freight onto sleighs or wagons and haul it the remaining distance over ice or land. (Courtesy of MHPC.)

In 1887, the *Bar Harbor Record* reported that "Somesville for a quiet place of rest is fast becoming a favorite resort," its central location making drives to interesting points convenient. The village's tranquil and humble nature especially appealed to ministers, including Rev. Horace Leavett, one of the first cottagers in Somesville. Many years later, in 1925, Rev. William T. Manning, bishop of New York, shown here, moved from Seal Harbor to Somesville. By the 1920s, about 11 summer cottagers, owned primarily by people from Massachusetts and New York, had been built, while others rented islanders' houses. (Courtesy of MHPC.)

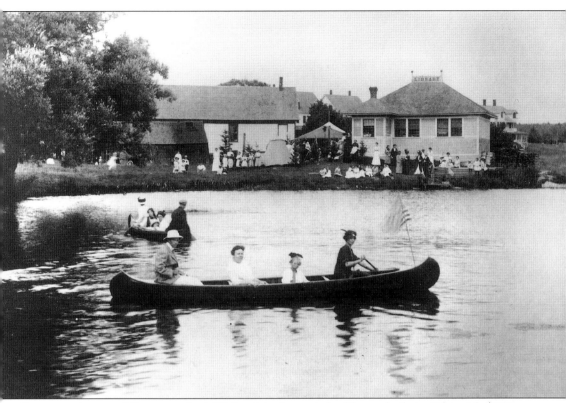

Canoers enjoy a paddle across the Mill Pond in front of the library, built in 1894 with $700 raised by the New Library Society of Somesville. Sociables and fundraisers, including a special drama presentation called *Little Brown Jug,* helped by generous donations from summer visitors, provided the funds. The library had its beginnings in 1884, when a few of Somesville's young ladies organized the Ladies Aid Society to gather books. In February 1886, they held a masquerade ball in the Grand Army of the Republic (GAR) hall, at which the newspaper determined that Arthur Somes was "unmistakingly the 'belle of the ball.'" The $45 in proceeds were used to purchase almost 200 books kept in A.C. Fernald's post office. On January 30, 1901, the *Bar Harbor Record* described Somesville's achievement: "The [library] building represents the enterprise of the people; the true index even more than church or school to the intelligence and enlightenment of the people of Somesville." (Courtesy of MDIHS.)

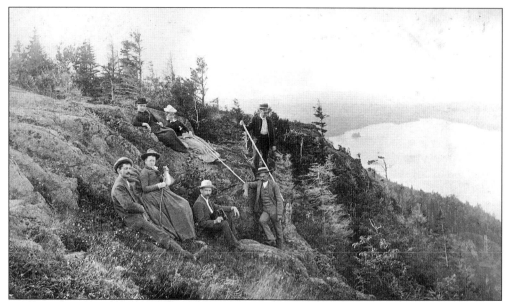

Walking sticks in hand, these rusticators have trekked up Beech Hill *c.* 1890 to its 400-foot precipice overlooking Echo Lake. Although the mountain was a common destination for nature walks, the Clark, Wasgatt, and Richardson families had discovered its rich soil and farmed the land early in the 19th century. This settlement was the reason that the original rough road between Somesville and Southwest Harbor traversed the top of this mountain until a new road, skirting Echo Lake, was built in 1837. (Courtesy of MDIHS.)

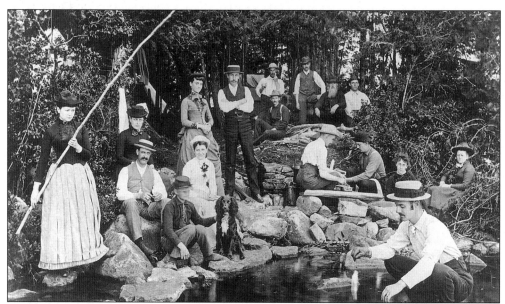

Although fancy Bar Harbor was the destination for some, others, like this group of men and women from Waltham, Massachusetts, sought a simpler vacation of camping beside Echo Lake around 1890. Here, they could pass the time fishing, hiking the hills and mountains, and possibly renting a buckboard for the famous 21-mile ride circling the island, accompanied by their trusted canine. (Courtesy of MDIHS.)

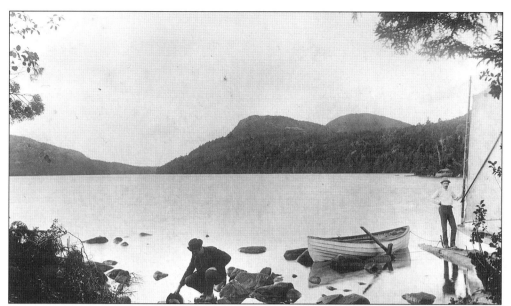

Joseph Caughey, right, and his friend are taking full advantage of Echo Lake, described in 1875 by Samuel Adams Drake as "a superb piece of water, having Beech Mountain at its foot. Broad shouldered and deep-chested mountains wall in the reservoirs that have been filed by the snow melting from their sides. There are speckled trout to be taken . . . and of course the echo is to be tried, even if the mount gives back a saucy answer." (Courtesy of MDIHS.)

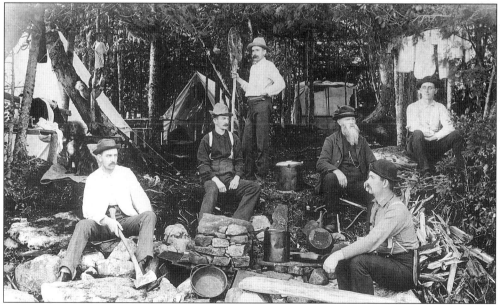

This is a souvenir photograph taken by photographer George Van Norman to remind the three Caughey men of their camping experience aside the shores of Echo Lake c. 1890. William Caughey, fourth from left, had emigrated with his family from Ireland to Ellsworth in the 1830s but later settled in Waltham, Massachusetts, to work in a watch factory. On this trip, he shared his love for the island with his sons Joseph and William, second and third from left. Successive family members continued to summer on the island for generations to come. (Courtesy of MDIHS.)

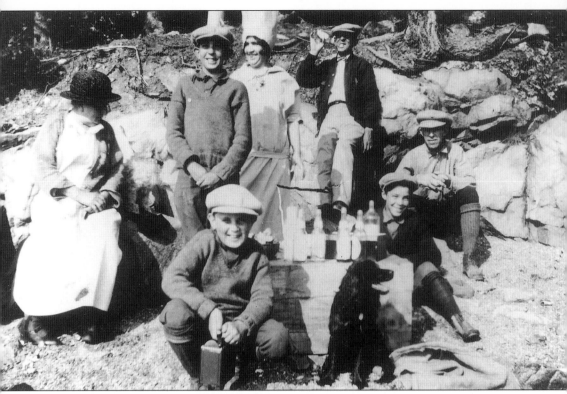

Catering to the visitors rarely gave Somesville's natives time to enjoy their wonderful surroundings. As the visitors returned to their winter homes, the island's year-round residents had time to resume their neglected friendships and activities. A typical fall scene is this picnic of the Daniel Somes Smith family, sharing cool drinks and stories of the summer passed on the rocky shores of Mount Desert Island. Many families would gather for clambakes and moonlit sails down Somes Sound. Island women worked toward community improvements through social groups, such as the Sewing Circle, organized in the 1850s, and the more recently established (1914) Village Improvement Society. The annual "Way Bak Ball" provided fun for the entire village. Held in February, residents would search their attics for costumes, and thus attired, join together and dance the evening away at the Masonic Hall to the music of Kelly's Orchestra. A quick entertainment pace was kept up with dances and dinners hosted by the Mount Desert Lodge, a local Masonic order, and its female counterpart, the Order of the Eastern Star. (Courtesy of MDIHS.)

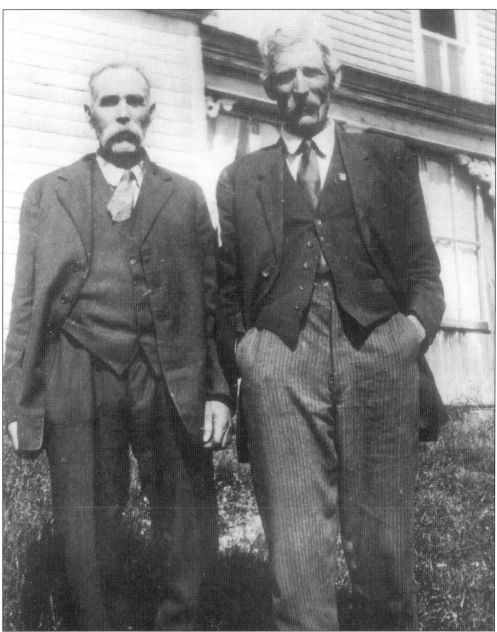

Jones Tracy (1856–1939) and his brother Henry Tracy Jr. are dressed in their best suits for this portrait in front of their family homestead, Fair Oak Farm. James and Rachel Gott Richardson, the Tracys' ancestors, settled this land on the eastern side of Somes Sound shortly after Abraham Somes settled on the western shore. Richardson, a highly educated and religious man, served as the first clerk of both the Mount Desert Plantation and the early Congregational church, formed in Southwest Harbor in 1792. When Bloomfield Richardson inherited the home, he added a fine new hall in 1893. The dedication ceremony on Christmas evening began with Santa Claus distributing gifts from the tree, followed by a grand ball. One could imagine that Jones Tracy, the island's most famous storyteller and the next to inherit the property, would have had the crowd enamored with his tall tales that evening. (Courtesy of Kay Moore.)

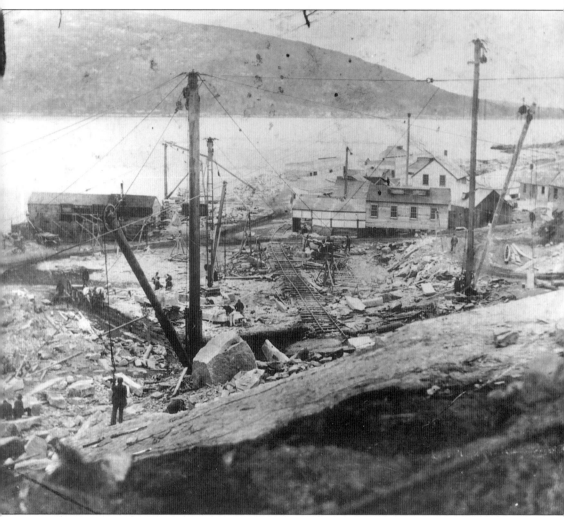

In 1871, Cyrus Hall, a native of Belfast, Maine, began quarrying granite commercially at Hall's Quarry, being the first of four companies to operate here in the 95-year history of its granite industry. He was known as a fair man, paying his employees union wages and not demanding that they live in the company's boardinghouses or buy from the company store, as did other granite companies in the state. He also arranged a place for the union men to hold their meetings. Many of his company's contracts he secured himself, traveling to Boston, Washington, New York, Philadelphia, and Chicago to do so. These contracts included the north and east porticos of the Illinois State Capitol, the Library of Congress in Washington D.C., and the U.S. Mint in Philadelphia. Trying to improve his company, he invented the three-legged derrick and the bull wheel derrick, both of which were important additions to the granite industry. (Caption by Juanita Sprague and Steve Haynes; photograph courtesy of MDIHS.)

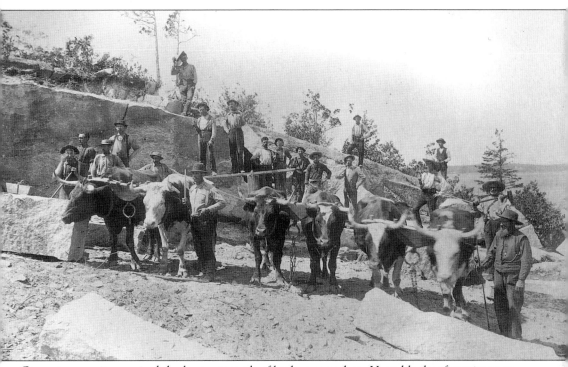

Quarrying granite required the brute strength of both man and ox. Huge blocks of granite were cut by hand from the quarry, loaded onto stone wagons, and hauled by oxen or horses to the cutting sheds. Italian, Swedish, Finnish, and Scottish laborers came in large numbers during the heyday of Hall's Quarry. During their 10-hour workday, the Italian and Scottish artisans generally did the fancy carving and were paid $2 per day, while the Swedes and the Finns worked in the quarries getting out the stone for only $1.50. Teamsters with their oxen or horses were paid $1.50 a day. One of Hall's Quarry's biggest contracts was that for Philadelphia's U.S. Mint in 1899. This contract called for one-half million dollars worth of granite and was awarded to the Standard Granite Company, of which Cyrus J. Hall was president. With 800 men on the payroll for this 18-month job, new boardinghouses were erected and four general stores were in operation. (Caption by Juanita Sprague and Steve Haynes; photograph courtesy of MDIHS.)

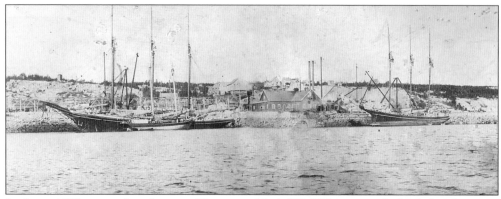

In this c. 1906 image, the schooners *Bloomer* and *Isabell E. Wiley* wait to be loaded with paving block at the granite works of Arthur McMullen at Hall's Quarry on Somes Sound. The stones are destined for Boston, New York, Philadelphia, or Hartford. The deep-water anchorage of Somes Sound allowed schooners to dock and load at the wharf at all times, not having to wait for high water, as did most of the granite operations along the Maine coast. (Caption by Juanita Sprague and Steve Haynes; photograph courtesy of MDIHS.)

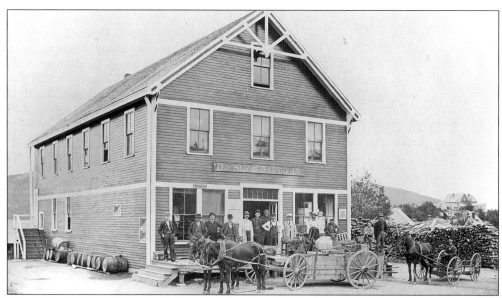

"The company store of the Standard Granite Company at Hall's Quarry carries workman's goods and personal supplies at prices well below retail prices," reported the *Bar Harbor Record* in 1899. "Because of this, the men can live very cheaply." At "Quarryville," so called before it received its present name, there was a post office and mail route and a school, which was erected in 1883 to accommodate 52 students. In 1890, it was filled past its capacity with 93 children. (Caption by Juanita Sprague and Steve Haynes; photograph courtesy of MHPC.)

Two
SOUTHWEST HARBOR

Henry H. Clark, commonly called "Deacon," and his wife, Caroline, opened the earliest summer hotel in Southwest Harbor, which expanded into several inns over 50 years. Although this enterprise kept Deacon busy during the summer months, shipbuilding, lumbering, and a bit of farming filled the remaining year. A local correspondent reported, "The [81-year-old] deacon is as busy as ever; you cannot hardly tell when to find him, and it is said that the quickest way to see him if you are in a hurry is to sit down and wait, and he will soon come along." (MDH, October 19, 1892.) A devout Christian, he not only led the effort to build the Congregational church but was always there to lend a helping hand to his brethren. When he passed away in 1897, it was said that Tremont had "lost its most honored and upright citizen one whose influence for good will long will be felt." (Courtesy of MDIHS.)

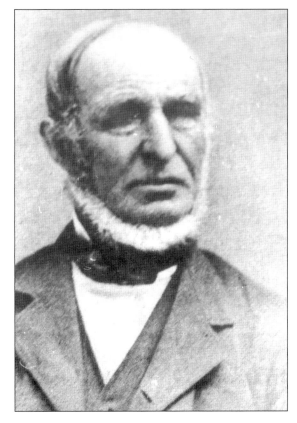

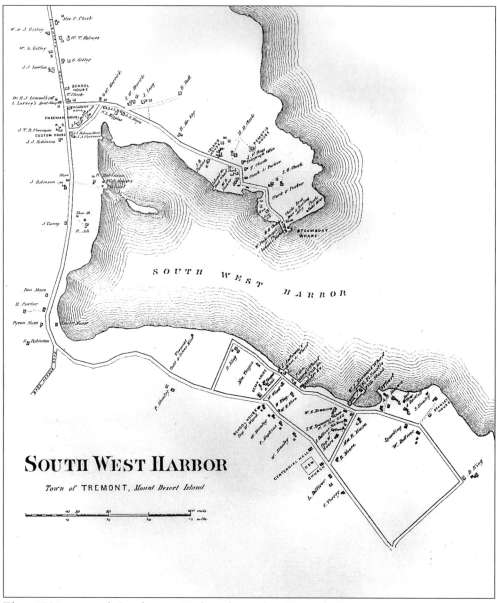

SOUTH WEST HARBOR

Town of TREMONT, *Mount Desert Island*

This 1881 map of Southwest Harbor from the *Hancock County Atlas* illustrates the configuration of the community: the northern peninsula of Clark's Point, the commercial district at the head of the harbor, and the village of Manset on the south side. George J. Varney's 1881 *Gazetteer of the State of Maine* cited Tremont, in which Southwest Harbor was located, as having a population of 2,011, whose income was "found chiefly in the sea." By 1881, however, summer hotels such as the Island House, the Freeman House, the Ocean House, and the Stanley House dotted the map, foreshadowing the importance of summer tourism. Not shown is McKinley, a village south of Manset, later called Bass Harbor. (Courtesy of MHPC.)

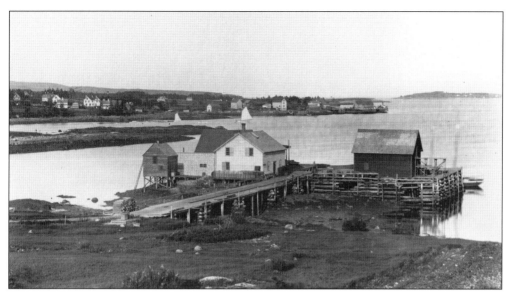

This overview of Freeman's Wharf (foreground, with Clark's Point behind it) offers a vision of Southwest Harbor in the late 1890s. Several of the newly established hotels emerge from the treeline, while several wharves dot the shore. The Clark family was still the dominant landowner on Clark Point at this time, while James T.R. Freeman had developed this land at the head of the harbor into a canning factory, which was owned by Alton E. Farnsworth. (Courtesy of Ed Wheaton.)

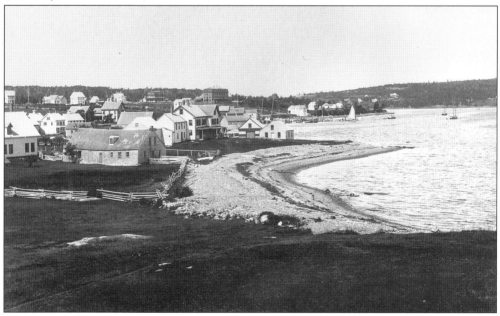

Taken from the Stanley House, this view of Manset highlights the segment commonly known as Haynes' Point, after its previous owner Andrew H. Haynes. In the distance, perched on the hill at center, is the Ocean House and its cottage. Manset's commercial center, where fisheries and their wharves jut from the shore among clusters of stores and chanderlies, lies halfway between. Albert Bartlett's sail loft, the closest building, was once the site where youngsters would travel long distances to dance the hours away on its rough floor. (Courtesy of Ed Wheaton.)

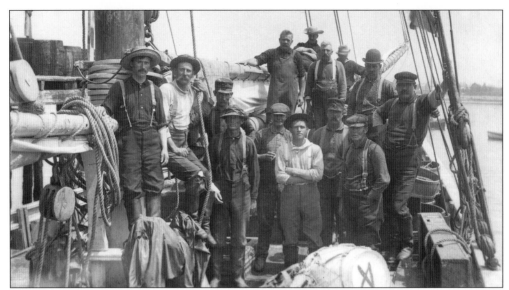

As the century turned, George Neal photographed the schooner *Emma*'s crew in Bass Harbor. The 80-foot vessel, named for the original captain's wife, Emma Stanley Spurling, was a mackerel schooner. By 1887, 33 fishing vessels were owned in Mount Desert, Tremont, and the Cranberry Isles, employing 152 men. The pay on fishing and coasting schooners was poor, averaging about $1 daily. On Mount Desert Island, where fishing and coasting tended to be family affairs, wages and vessel conditions were better than average. (Photograph by George Neal; courtesy of SWHL.)

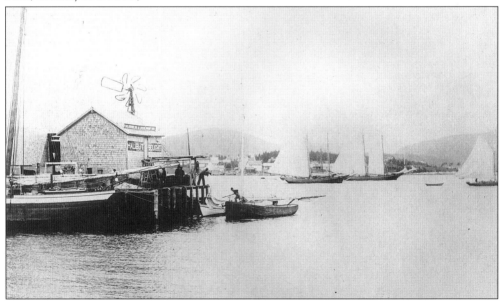

Beside James Parker's shed, capped with a small windmill, men are loading a seine boat with salt *c.* 1891. Salt, a preservative for fish, was needed in great quantities, about 30,000 hogsheads full a year for this company. During this period, fish curing and canning businesses in Manset and Bass Harbor were flourishing, giving rise to friendly competition between neighboring villages. The winner did not matter, as the rise in business meant much needed employment for the islanders. (Courtesy of MHPC.)

40

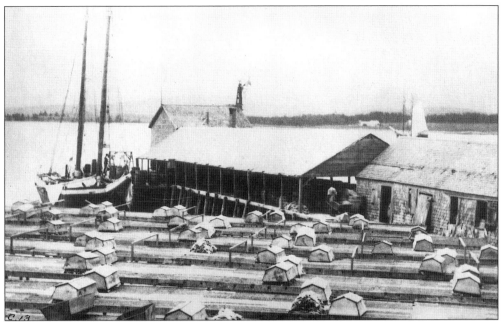

By the mid-1880s, dried cod was becoming a major export from Manset. Fish merchants such as Asher Allen would purchase cod from local fishermen, salt the fish, and lay them to dry on long tables, like the ones seen in this 1891 photograph. Nightly, or during inclement weather, the fish would be bundled under the small houses. Asher Allen, who worked for a Boston firm, started in Manset in 1882. Within four years, he was purchasing over 7,000 quintals of fish annually, equal to 1.54 million pounds. Soon after, however, he became proprietor of the Ocean House. (Courtesy of MHPC.)

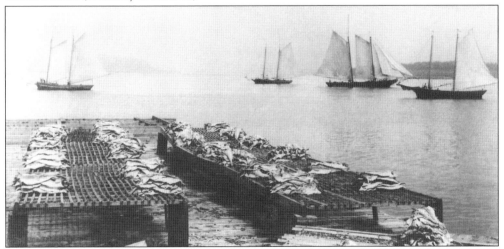

While the schooner *Bouquet* (far right) and its adjacent "sharp shooter" vessel lay anchored in Southwest Harbor, fish are flaked out, drying in preparation for shipment to markets. When Henry Rand took this photograph in 1892, six firms were curing or canning fish in Manset and Bass Harbor: Parker Brothers, J.L. Stanley, Wells and Mayo, Farnsworth's Cannery, William Underwood & Company, and P.W. Richardson. Allied industries, such as the ice producers J.L. Stanley & Sons, chandleries, and dry goods stores were ready to serve and profit from these prosperous times. (Courtesy of SWHL.)

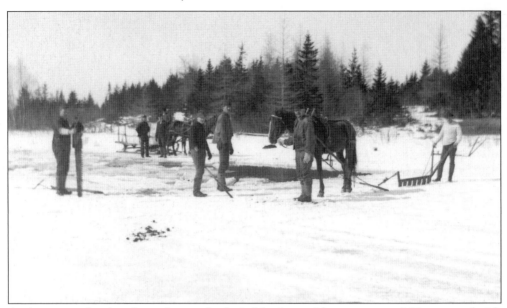

As Americans developed a preference for fresh fish, demand for ice increased. Here, armed with a handsaw, ice chisel, and ice plow (at right), these seven men are harvesting ice, which rivaled granite in the 1890s as Maine's prime export. In Manset, John L. Stanley supplied ice to fishermen. He not only owned a pond and icehouses but extended his wharf several times for ice delivery to fishermen, even at low tide. (Courtesy of SWHL.)

One would expect to find James Albert Parker, eldest son of the prosperous James Parker, on the wharf. In the 1880s and 1890s, James Parker and his four sons developed the largest wholesale fish business in Maine, with a fleet of 15 to 20 vessels, about 150 men, and distributing about $100,000 in payroll annually. Moving closer to their business, in 1890 the Parkers bought William Stanley's house, the former Harbor House, which continues to serve the public as the Moorings Restaurant today. (Courtesy of the Parker family.)

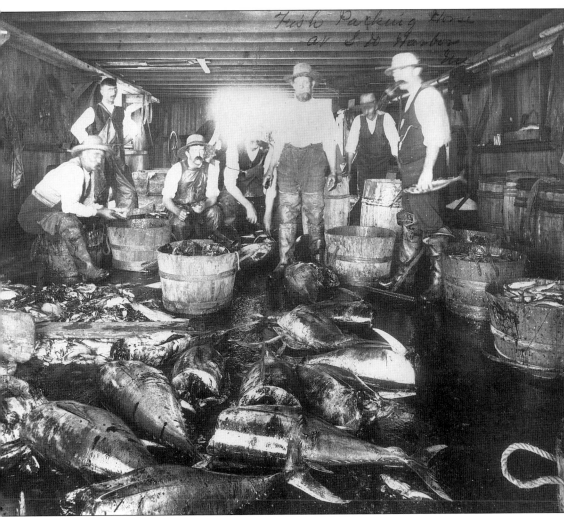

The catch, probably tuna (called horse mackerel locally), has arrived at the packing house, having been dressed on board vessel. Now it is up to this hardy packing crew to wash these monstrous fish before packing them for shipment to Boston. Except for Asian markets, which existed mostly in large cities, there were few buyers for this product. At other times this packing house was filled with the more predominant fish of the day: hake, cod, haddock, and mackerel. Crews would wash the fish, lather them with salt, and pack them in ice in the tall barrels shown at rear for shipment to Gloucester or Boston. Only a few dealers in Manset, such as the Parkers, specialized in halibut, as it had to be shipped fresh on ice. Mackerel was the only product that had to be inspected once it arrived in Gloucester. As this list suggests, local fisheries processed a variety of fish. The local fishermen would head out, from spring through fall, following the schools, returning with whatever the sea would offer, and putting extra change in their pockets. (Courtesy of MHPC.)

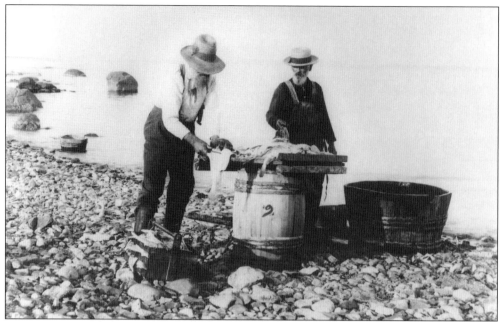

In 1892, photographer Henry Rand found the Dolliver brothers dressing fish along the Seawall shore, shaded from the hot August sun by their broad brimmed hats. The two fishermen were probably putting up some fish for their winter dinners, as fish formed a large part of the coastal diet. After they finished their work here and took their fish home in their clam roller box, nature would clear their debris with the rise and fall of the tides. (Courtesy of SWHL.)

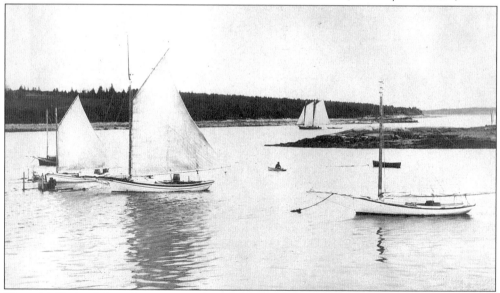

These McKinley lobster boats, original to the area, are anchored off Try House Point in Bass Harbor, awaiting their captain. The type of sloop became popular for lobstering, as it was small enough for one man to handle while setting and raising his lobster traps. The captured crustaceans were stored in cars, the submerged pens shown on the left. Lobsters were once considered so worthless that they were not taxed like other fish. That quickly changed as people developed a taste for the lobster. (Courtesy of MHPC.)

In the 1850s, William Underwood built this cannery on Deacon Clark's wharf in Southwest Harbor. In 1866, the plant boiled more than 2,500 crustaceans daily. Typically, men and boys unloaded the catch, made the cans, and sealed them, whereas women and children were constantly the industry's sorters and packers, at half the salary of men. (Courtesy of MHPC.)

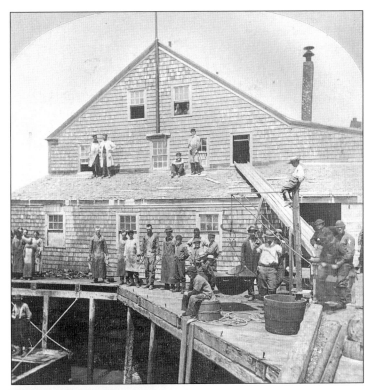

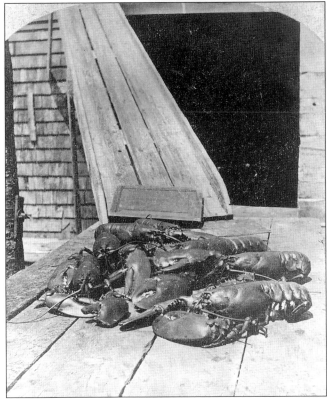

The crew of the sloop *Forest Home* took a tour of the lobster factory in 1866 and observed that "the lobsters grow to a large size, some weighing as high as seventeen pounds, although the average is . . . probably not over four or five. Two large cauldrons are kept constantly filled with boiling seawater, and into these fiery purgatories one hundred poor insects are thrown at a time. . . . Two thousand five hundred boiled lobsters spread out in one room was a novel sight; they were suggestive of a miniature army of red-coated British grenadiers drawn up on parade." (*Cruise of the Forest Home*, pages 113–115; courtesy of MHPC.)

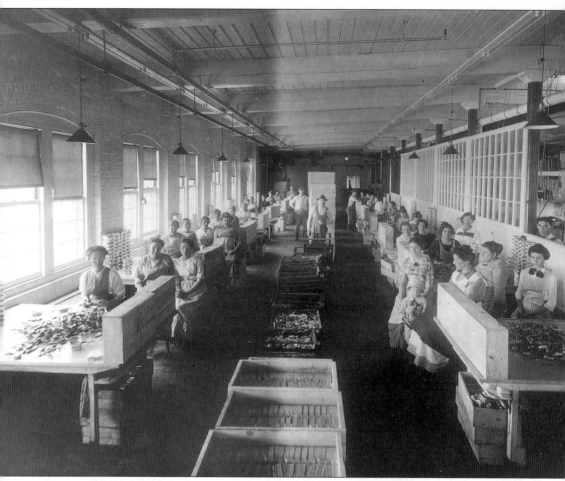

Deacon Clark's wharf, the location of the lobster factory, doubled as the steamboat wharf. Early rusticators were willing to tolerate the "unpleasant" smell of the factory, but by 1886, blatant criticism, coinciding with desires to expand the plant, resulted in its move to the McKinley shore, adjacent to P.R. Richardson's general store. In 1902, the company expanded, erecting this two-story brick factory. Similar to the Clark Point location, McKinley offered access to P.R. Richardson's newly expanded wharf, which allowed steamer landings at low tide. Another key resource was the available work force. These women, clustered around the sorting tables, were thankful for the work, though seasonal. Boys, with their small, adept fingers, were employed to sort and cut the fish, earning 25¢ a day. At times they were also employed to row the discarded shells out into the middle of the harbor for disposal, a task that almost cost nine-year-old Luke Newman his life when his boat capsized. Luckily, the Mount Desert Life-Saving Station came to the rescue. (Courtesy of MHPC.)

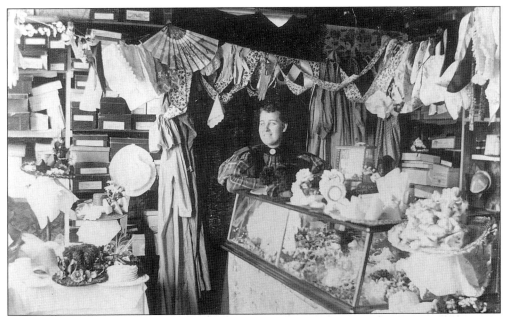

Milliner Nora Grindle shows off the latest 1897 styles of bonnets, fans, and other "fancy goods" she purchased in Boston on her semiannual buying trip. She was a newcomer to the business, compared to her Southwest Harbor counterpart, Emily Robinson Farnsworth, a 20-year veteran who ran the post office out of her store. Although Emily Farnsworth finally succumbed to Addison Farnsworth's marriage proposal, Nora Grindle and Octavis Fifield, Nora's business's predecessor, expanded the enrollment in their "Bachelor Girls" club, "making the boys go home alone." (BHR, March 31, 1897; courtesy of MHPC.)

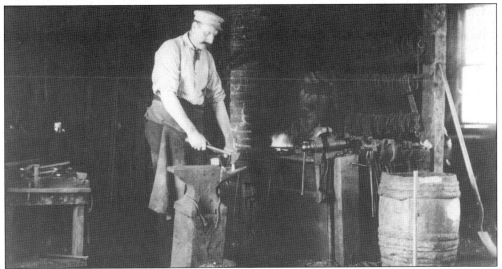

Edwin Higgins' shop was dimly lit, enabling him to see the subtle color variations in hot metal. The light, however, posed a challenge for photographer Henry Rand *c.* 1894. Higgins started a local blacksmith shop in the early 1880s, when few people had horses. A decade later, when horses, carriages, and carts were more common, Higgins' centrally located shop, near the corner of Clark and Main Street, was a busy place. He also welcomed William Tower, the carriage maker, as a neighboring business. (Courtesy of SWHL.)

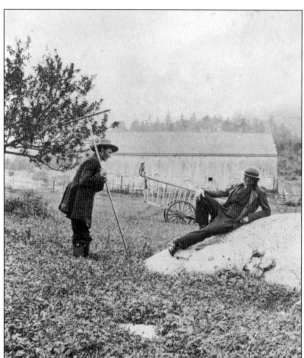

On Fernald's Point, under the misty Carroll (Flying) Mountain, these two rustic New Englanders are having a courteous consultation on the weather while paying no heed to the passage of time. Behind them, their companion waits patiently, perched on the empty hay rack. Over the years, many had settled this point, starting with the Native Americans and followed by a French Jesuit mission. The English drove the mission away, leaving the land to New England settler Andrew Tarr and his descendant Capt. Daniel Fernald, for whom the point is named. (Courtesy of MHPC.)

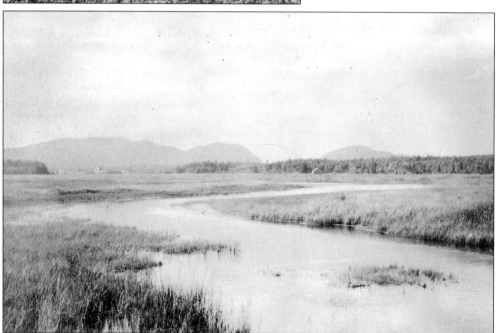

The Western Mountains (Bernard and Mansell), at left, along with Beech Mountain, at right, provide an elegant backdrop for Bass Harbor Marsh, where salt hay, highly valued as nutritious fodder for local livestock, grew. In the 19th century, most island families were subsistence farmers with a few oxen, cows, and pigs, and they depended on this hay for feed. Every July, families would congregate here to harvest the hay. Today, tourists photographing beautiful sunsets is the only activity at this marsh. (Courtesy of NEHL.)

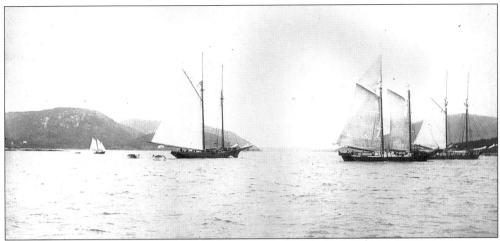

Off Southwest Harbor, a small group of coasters lie at anchor with mainsails hoisted. The days were waning when one would see 150 or more white-winged coasters and mackerel schooners lying in this bay awaiting a storm's passage. Steamers and railroads were giving these vessels competition. For a time, Mount Desert and Tremont's production of ice, granite, canned fish, cured fish, and lumber supported the fleet, but soon the only white sails were those of pleasure yachts. (Courtesy of MHPC.)

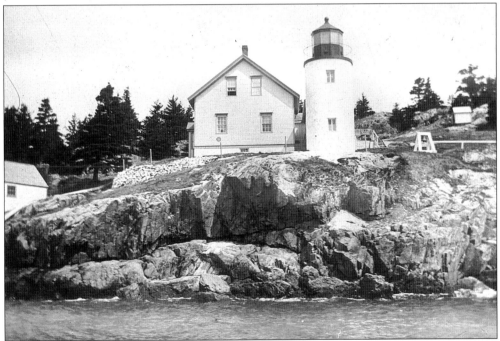

On August 18, 1856, Congress appropriated $5,000 to establish a light station at Bass Harbor Head as a means to assist vessels in entering the nearby harbor. The Lighthouse Establishment's district engineer, Lt. W.B. Franklin, designed the brick lighthouse and its connected frame keeper's house, which was originally clad in brown board and batten siding. The facility went into service in 1858. This c. 1895 photograph shows the light station shortly before the hand-operated fog bell in its timer A-frame (to the right of the tower) was replaced by a brick fog signal house. (Courtesy of MHPC.)

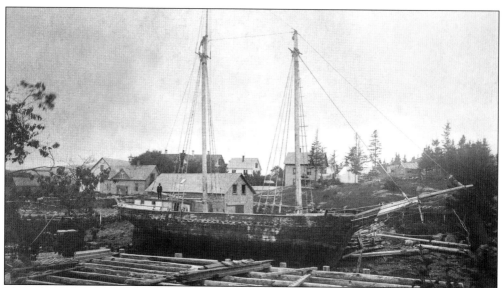

The schooner *Palestine*, deserted here in Deacon's Harbor, was painted repeatedly by visitors. Behind the hull can be seen the workshops for Deacon Clark's shipyard business and the Henry Clark and William Parker Chandlery. Higher on the hill are the houses of the deacon's children: daughter Ada, her husband William Parker (left), and son Henry. Each summer, Native Americans would return to their camping spot on the ridge, visible just above the bow sprit. (Courtesy of SWHL.)

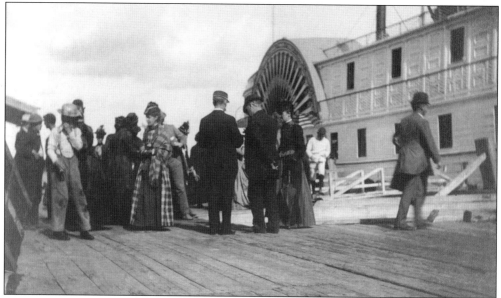

The steamer *Mount Desert*, dressed in her bright striped paddle wheel with gilded overtones, patiently waits at the Southwest Harbor wharf while her formally attired patrons check their tickets and bid their farewells on September 2, 1890. The baggage handlers, who were islanders, have taken care to load trunks and luggage on board. Now that the travelers have discovered the island's natural beauty and its comfortable inns, they have probably secured rooms for the following year, making their Mount Desert summer a tradition. (Photograph by Henry Rand; courtesy of SWHL.)

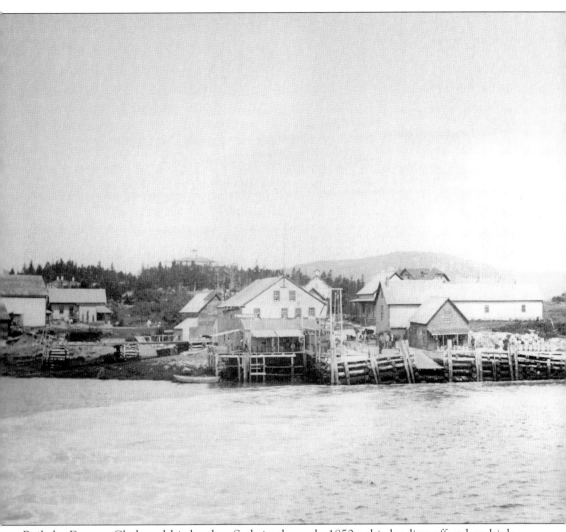

Built by Deacon Clark and his brother Seth in the early 1850s, this landing offered multiple services catering to the needs of mariners and summer visitors. Clark and Parker's chandlery had expanded into the building at the far left. To its right, Albert W. Bee, the leading newspaper agent in Bar Harbor, had established a store offering newspapers, stationery, fruit, and confections in the summer months. In order to oversee this business, Bee also built his family a summer cottage called Sleepy-Hollow nearby. In 1890, W.H. Joyce transformed the old lobster factory, center, into a steam-powered gristmill, and Merrill King sold fish from the shed attached to the building. Visitors and locals needing a horse or carriage could find them at Augustus Clark's livery stable, located behind his bowling alley, at right. The islanders and entrepreneurs were ready to welcome the business. (Photograph by Henry Rand; courtesy of SWHL.)

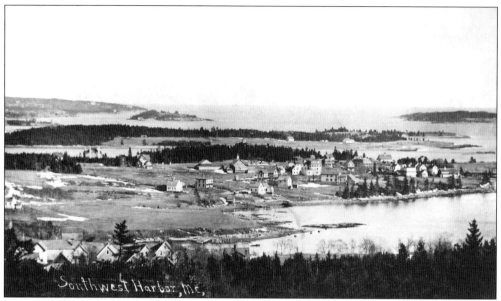

From high on Freeman's Hill, one can view the development on Clark Point, an area once owned by the island's first minister, Rev. Ebinazer Eaton. Deacon Clark's hostelry and the William Underwood & Company spurred development on this point. Many of the residences belong to Clark family members. Storekeepers and tradesmen drawn to the area for work were settling here as well. Far off in the distance, the towers of Robert Kaighn's elaborate 1892 summer cottage signal the beginnings of the summer colony. (Courtesy of SWHL.)

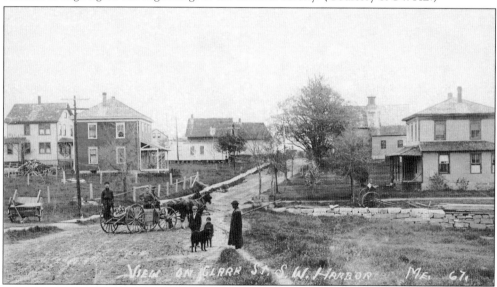

Youngsters Lawrence Phillips, left, and John Lawler watch as the wagon crew unreels telephone wire on Clark Point Road. Communication to the mainland once consisted only of twice-per-week mail to Somesville and news brought by mariners. Deacon Clark organized the island's first telegraph office in 1869, connecting his community with Somesville and Ellsworth. Southwest Harbor waited another 14 years to have a public telephone office, linking the town to the neighboring harbors and mainland. Now, in 1913, connecting the homes to the line would be next. (Courtesy of SWHL.)

In 1884, the *Mount Desert Herald* reported that 71 families in Southwest Harbor were served by only one meetinghouse. To address the need for a church on the north side of the harbor, the Congregationalists and the Baptists joined forces to construct a union meetinghouse on Dirigo Avenue between 1883 and 1885. Built by James T. Clark and dedicated on September 9, 1885, this striking Queen Anne church featured a prominent corner tower with an open belfry. (Courtesy of MDIHS.)

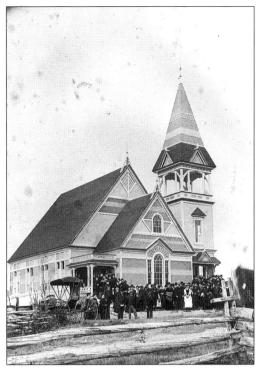

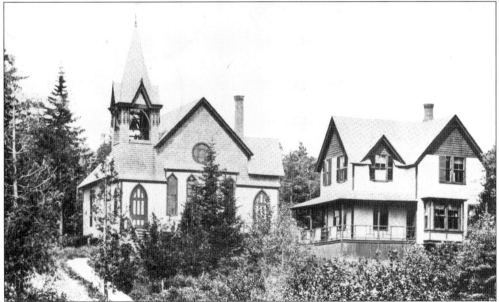

The Methodists quickly followed the lead of the Congregationalists and Baptists by building their church in 1889. The design, a pleasing blend of Gothic Revival and Queen Anne elements, was obtained from the prolific Philadelphia architect Benjamin D. Price, who planned Methodist and Baptist churches throughout the country. Local builder R.F. Lurvey constructed the church for $2,500. The building was dedicated on August 9, 1889, with two services, from which came $1,000 in offerings to free the church from debt. The Queen Anne parsonage at the right was added in 1895. (Courtesy of MHPC.)

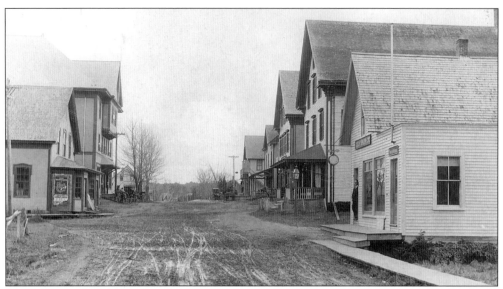

Southwest Harbor's commercial area is shown here c. 1900. At the left is the 1875 Tremont Hall, which was acquired in 1881 by the Masons, who met on the second floor. This space was shared with the Odd Fellows when they formed a lodge in 1893. Four and a half years later, the Odd Fellows moved into their own hall next door. Across the street from these fraternal halls, the five buildings are, from left to right, J.T.R. Freemon's clothing store, Dr. J.D. Phillips' residence, A.I. Holmes' general store, the Holmes House hotel, and J.C. Ralph's jewelry store. (Courtesy of MHPC.)

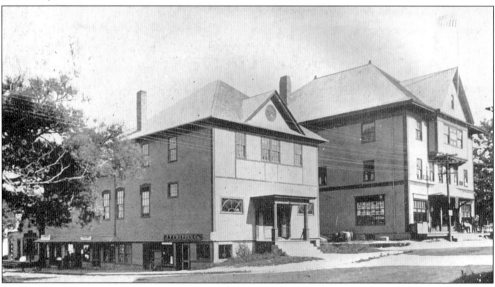

In this c. 1905 postcard view, the enlarged Masonic Hall, left, stands next to the Odd Fellows Hall. The Tremont Masonic Lodge, which had been organized in 1854, purchased Tremont Hall on Main Street in 1881, which they dedicated as Masonic Hall in 1883. This structure was moved back and raised a story in 1903 to form the rear of a new Masonic Hall. The new hall, with a hipped roof and gabled facade, complemented the adjacent Odd Fellows Hall. In the March 1922 fire, the Masonic Hall sustained serious damage but was soon repaired. (Courtesy of MHPC.)

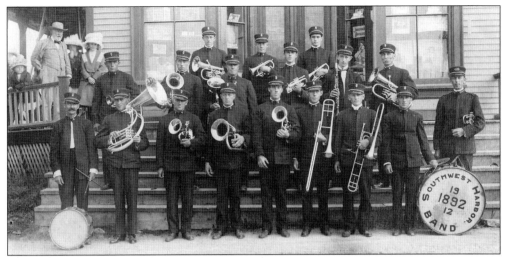

Formed in 1882, the Southwest Harbor Band had been an integral part of the community for 30 years when it assembled for this *c.* 1912 photograph. On Memorial Day and the Fourth of July, the group marched in the annual parades and played patriotic tunes. During the summer months, they gave concerts in the municipal bandstand. The Southwest Harbor Band was also frequently in demand to provide music for balls and dances. On July 27, 1895, the *Bar Harbor Record* reported that the band had participated in an excursion to Islesford on the *Golden Rod* and had played for a dance on the island. (Courtesy of SWHL.)

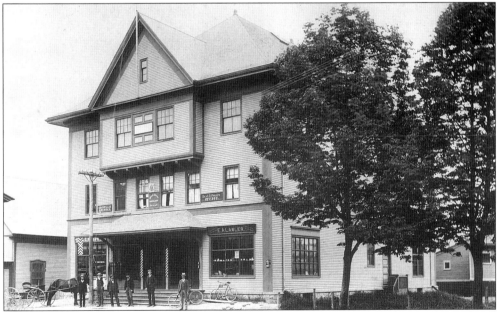

The Pemetic Lodge of Odd Fellows was organized on May 7, 1893. After sharing the Masons' quarters for four and a half years, the Odd Fellows built this handsome block in 1897 for $9,000. The first floor was occupied by grocery and dry goods stores, while second floor offices accommodated Dr. J.D. Phillips, attorney George Fuller, insurance agent Charles Grant, and the New England Telephone exchange. The third floor was devoted to the Odd Fellows' lodge and banquet hall. The building was destroyed in the March 1922 fire and was rebuilt the following year. (Courtesy of MHPC.)

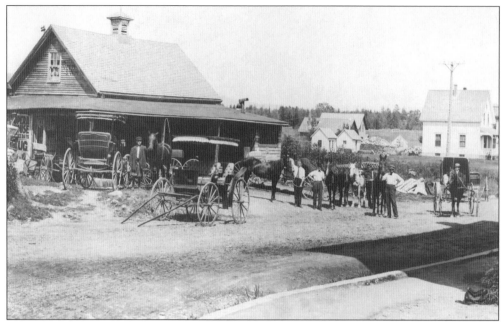

By the beginning of the 20th century, fewer families could justify owning oxen, once the power behind the lumber- and ice-hauling industries. More commonly, families would hire horses and carriages for special events. There to serve this need was P.L. Sargent, whose livery stable stood on Clark Street, just east of Main Street. A practical buggy could be rented for errands, or a surrey complete with fringe could be leased by those wishing a fancier outing. (Courtesy of SWHL.)

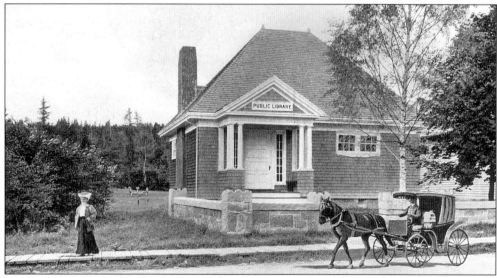

Between the Civil War and World War II, many Maine communities built public libraries. The effort for a Southwest Harbor Public Library begun by Annie Sawyer Downs in 1884 culminated in 1895 with the construction of the original portion of the present building. Designed by architect and summer resident Eleazer B. Homer, the library was a rectangular, hip-roofed structure, sheathed in shingles on the exterior and lined with bookshelves for 1,000 volumes on the interior. Local contractor Melvin Norwood constructed the library for $898, and the dedication was held on October 3, 1895. (Courtesy of MHPC.)

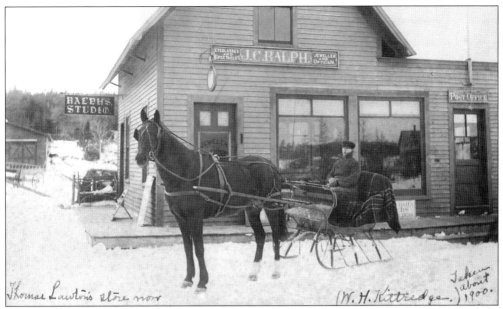

Jeweler John C. Ralph moved from Bar Harbor to Southwest Harbor in 1888 to open a jewelry window in J.T.R. Freeman's store. Over the course of his 22-year tenure in Southwest Harbor, this ambitious man established many businesses, as his storefront depicts. He built this store in 1895, just as he expanded into optometry. Making bike repairs and serving as postmaster and constable soon followed. As described in the newspaper, Ralph never walked when he could run. (Courtesy of SWHL.)

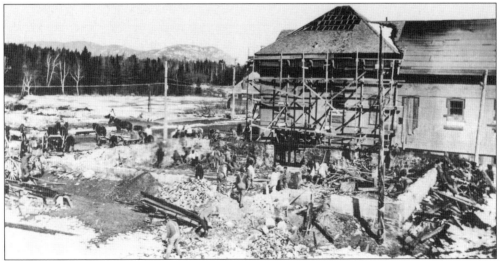

The worst fire in Southwest Harbor's history leveled much of the business district in the early morning hours of March 27, 1922, destroying $150,000 worth of property. Starting in the Holmes Store, the fire spread to the Carroll, Ralph, and Lawton buildings as well as the Odd Fellows Hall across the street. All five structures were lost, while the Dudley residence, the Park Theater, and the Masonic Hall were badly damaged. The fire was stopped at the Masonic Hall through the valiant efforts of local volunteer firefighters. In the following months, the Masonic Hall was repaired and downtown commercial blocks were rebuilt, including a new Odd Fellows Hall. (Courtesy of SWHL.)

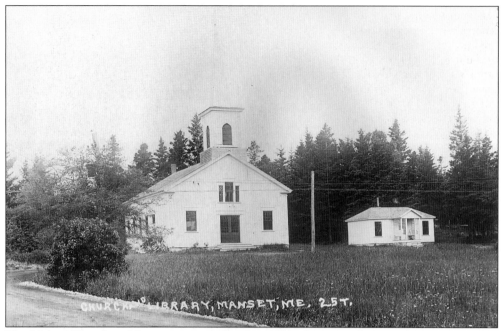

The Union Church at Manset was completed *c.* 1828 after several years of construction. Its location on the south side of the harbor made it accessible to those living in Bass Harbor and on the Cranberry Islands. In the early 20th century, the Manset Village Improvement Association organized a library, which was first housed in a 12-by-12-foot building. Later this structure was moved to the site next to the church and enlarged into a small hip-roofed building with a portico. (Courtesy of MHPC.)

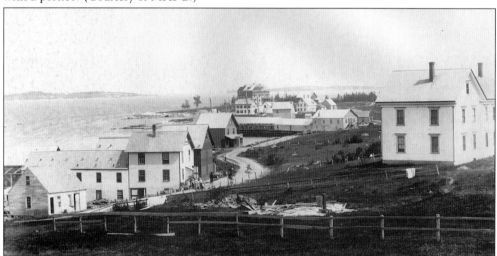

Before the days of summer boarders, Manset, shown here, was the hub of Southwest Harbor. The only post office south of Somesville lay in this corridor, along with the customs house and shipbuilding and fishing operations. By the 1890s, there were post offices on both shores of Southwest Harbor. Seen here is William Ward's house, right, overlooking his wharf on the shore, which housed his store and bowling alley. The adjacent wharf is where John L. Stanley operated his ice and fisheries businesses, and Lewis Newman's meat market lies further at left. (Courtesy of Ed Wheaton.)

The name Centennial Hall denotes that this large frame building in the center of Manset was built in 1876, the year of the nation's 100th anniversary. The upper floors hosted the village's many social and political gatherings. One such event, the ninth annual masquerade ball, was held in 1884. Preparations were extensive. Mr. Joy primed the islanders' feet with dancing lessons, while a costumer from Rockland clothed them appropriately. (Courtesy of MHPC.)

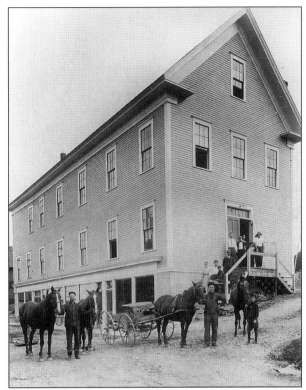

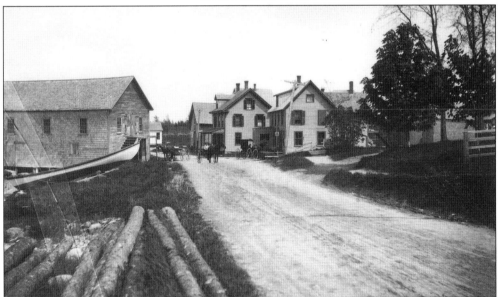

Farther east along Manset's Shore Road stood another cluster of stores and wharves serving local fishermen and coaster crews. Along this section of the Shore Road, the names Newman, King, and later Parker dominated. At the right, S.W. Newman's general store, Melvin Moore's grocery store, and Mrs. King's post office, which eventually became an undertaker's shop, await their customers. An elegant seine boat, left, is pulled up beside one of the wharf buildings. (Photograph by George Neal; courtesy of SWHL.)

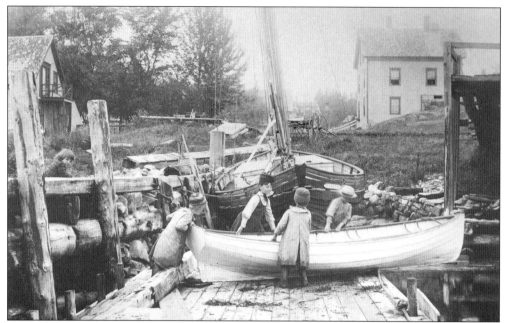

With all their might, these four young children are trying to launch their lapstreak skiff into the water, while their friend watches photographer Henry Rand on this cool August day in 1892. The Nova Scotian pinky *Zania* has outlived its usefulness as a trader's boat and lies abandoned here in Clark's Cove. (Photograph by Henry Rand; courtesy of SWHL.)

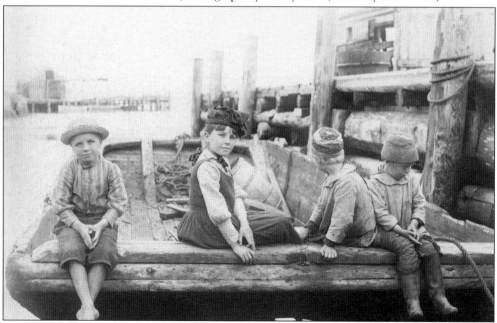

Photographer Henry Rand labeled this photograph as showing Fred, Jack, and Willy Parker on August 10, 1892. The mystery remains who is who and if the nicely dressed young girl is a sibling. The life of a child in the 1890s was not entirely carefree. Household chores were part of their daily routine and some worked in sardine factories, picking blueberries for market, or raking hay for $1 per day or less. (Courtesy of SWHL.)

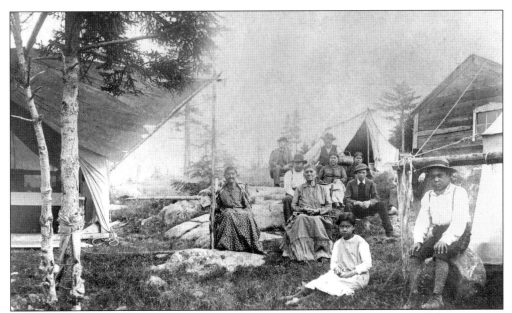

Native Americans from Oldtown, Maine, both young and old, returned each summer, pitching their tents on this rocky ledge above Deacon Clark's cove. For several months, they quietly went about their business, weaving baskets from the locally gathered sweet grass, beading intricate goods, and selling these wares to year-round residents and summer people. At times, they were even called upon to make baskets for the sardine factory. In September, this picturesque scene would disappear as they returned to the mainland. (Courtesy of SWHL.)

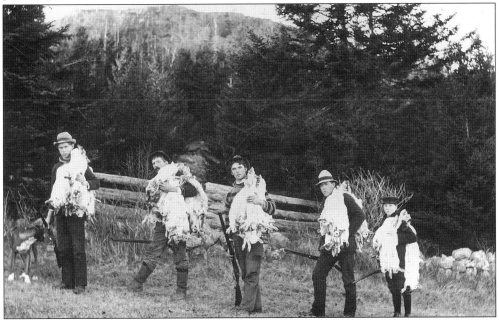

As they trekked down Flying Mountain after a magnificent December day of hunting, Lloyd Carroll, Jones Tracy, Fred Tracy, Guy Robinson, and young Charlie Ray are ready to boast of their jack rabbit catch. Wild game hunting each fall was almost as common a pastime for local men as the tall tales they spun about their expeditions. (Courtesy of James Carroll.)

Built by Nathan Clark in 1816, this sturdy Cape on Clark's Point is one of Southwest Harbor's oldest houses. Clark was among the local men who resisted the British during their raid on Mount Desert Island in August 1814. Captain Clark was the first of his name in Southwest Harbor, and his home has remained in the family through succeeding generations. Coming to visit are Mrs. Bee and her two children, right. (Courtesy of SWHL.)

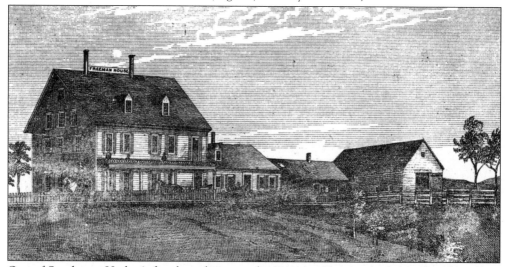

One of Southwest Harbor's first hostelries was the Freeman House, which stood in the village at the head of the harbor until its destruction by fire in February 1894. The original part of the Freeman House was built as a Cape c. 1825 by John Clark, whose widow, Margaret, married James Freeman. Their son James T.R. Freeman took in guests as early as 1851 and, in 1859, added a large two-story Greek Revival hotel, which he operated year-round with accommodations for 50 people. An ell and barn connected to the house completed the complex until additions were made in the 1880s. In the 1888 *Chisholm's Mount Desert Guide Book*, M.F. Sweetser described the Freeman House as "a fair-sized hotel with annex, looking down the quiet haven and so on out to sea." (Courtesy of MHPC.)

Near the steamboat landing on Clark's Point, Henry H. Clark established the Island House in 1850 to accommodate summer visitors. By 1859, Clark had enlarged his inn to host 40 guests, and the later addition of two more buildings would increase that number to 125. According to B.F. DeCosta's 1878 *Hand-Book of Mount Desert*, the Island House was "unsurpassed as a center for excursions, sail and row boats are always ready, and horses and carriages may also be had on very reasonable terms. There is excellent sea and trout fishing." A simple fare of chowders and brown bread headed the hotel's menu. (Courtesy of MHPC.)

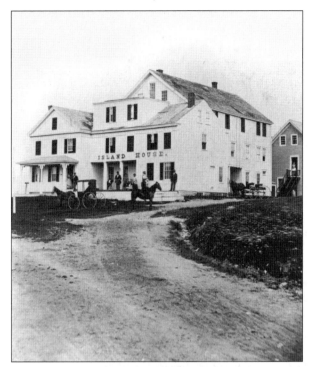

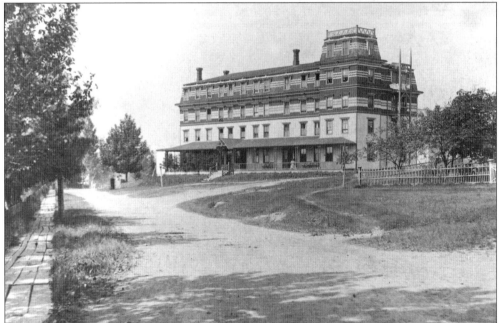

The Island House prospered for nearly five decades under the direction of Henry H. Clark. In 1882, Clark transformed his Greek Revival–style inn into a 250-guest hotel with a mansard roof; he made further additions in 1885. From the corner tower, according to the *Bar Harbor Record* of 1895, visitors could view "a range of mountains in the form of a semi-circle making an exceedingly artistic picture of nature." The Island House closed in 1900 and was later dismantled. Part of its salvaged materials were used to build two houses. (Courtesy of SWHL.)

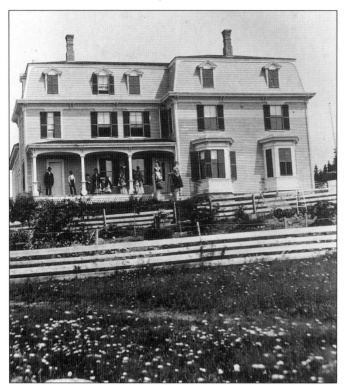

Prior to his enlargement of the Island House in 1882, Henry H. Clark addressed the need for expansion by constructing the Prospect House in 1870. Located adjacent to the original inn, this stylish mansard-roofed building gave the welcoming appearance of a fashionable home of the period. In his 1878 *Hand-Book of Mount Desert*, B.F. DeCosta described the Prospect as having "twenty-two rooms, all well lighted, and ventilated, furnished with spring beds. The halls and piazzas are wide and airy." After the closing of the Island House, the Prospect House became a private residence, which it remains to this day. (Courtesy of MHPC.)

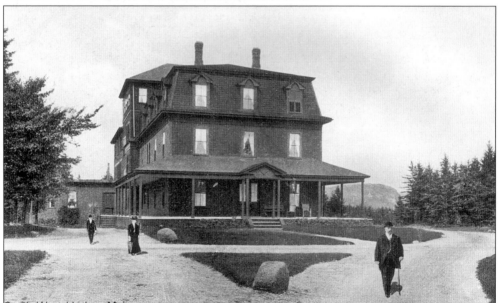

Cummings H. Holden opened a summer boardinghouse in Southwest Harbor in 1875. In 1881, the Holden House was replaced by the Hotel Dirigo, located behind the Island House. With an initial capacity for 60 guests, the mansard-roofed Dirigo took its name from the Maine state motto "I lead." After Holden's death, his nephew S.R. Clark enlarged the hotel and ran it until its acquisition by Leslie S. King in 1923. The King family maintained the popular Dirigo until its destruction by lightning in 1960. (Courtesy of MHPC.)

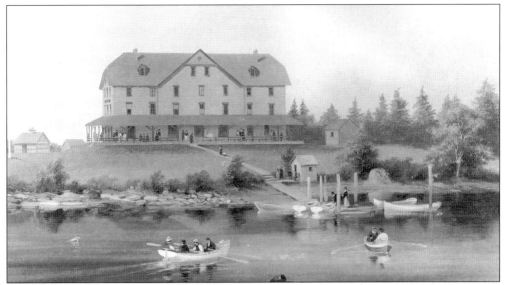

Of Southwest Harbor's many Victorian summer hotels, only the Claremont remains in operation. Built in 1883–1884 by Edward Glover of Rockland for retired sea captain Jesse H. Pease, the Claremont is depicted in this 1885 painting by Xanthus Smith at the dawn of its long history. Public sitting rooms and a dining room occupied the ground floor, while the three upper stories contained bedrooms with one bathroom to each floor. After Pease's death in 1900, his wife, Grace, ran the hotel until she sold it in 1908 to Dr. Joseph D. Phillips, whose family owned it for the next 60 years. Since 1968, current owners Allen and Gertrude McCue have upheld the Claremont's proud tradition of "plain living and high thinking." (Courtesy of MHPC.)

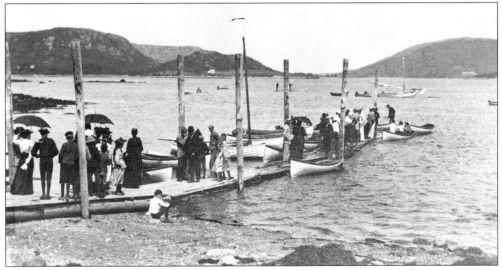

Having spent many years at sea, Captain Pease appreciated the enjoyment his guests would derive from sailing or fishing on Somes Sound. He equipped a dock in front of the Claremont with several rowboats for their use, as seen in this 1890s view. On May 31, 1899, the *Bar Harbor Record* reported that "Mr. Pease has just completed a new pier, 75 yards long at the end of which is a new boat float. A house for oars and to accommodate the man in charge of the boats, has been erected at the land end of the pier." (Photograph by Henry Rand; courtesy of SWHL.)

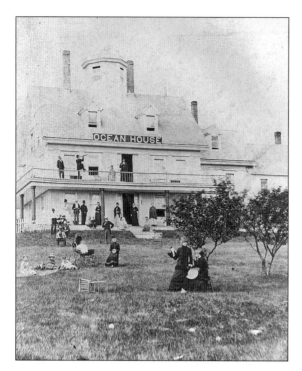

Horace Durgain, an entrepreneurial merchant and shipbuilder, erected this impressive Greek Revival house, complete with cupola, on the south side of the harbor in Manset c. 1850. During the 1860s, Nathaniel Teague converted Durgain's home into a summer hotel known as the Ocean House. This 1880s view shows guests enjoying a summer day on the front lawn as well as on the columned porch that surrounded the hotel. (Courtesy of MHPC.)

One of the features of a stay at a summer hotel like the Ocean House was the opportunity for a healthful daily outing to nearby mountains, whether on foot, on horseback, or by carriage. These Victorian rusticators of the 1870s are camped on Dog (St. Sauveur) Mountain for a meal supplied from two metal lunch pails, perhaps to be supplemented by the fish in the foreground. (Courtesy of MHPC.)

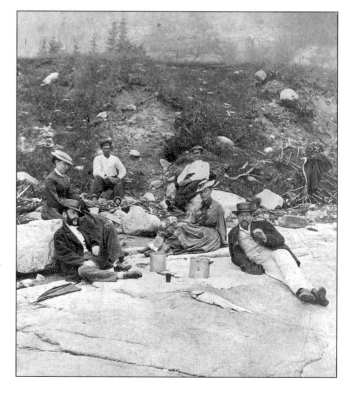

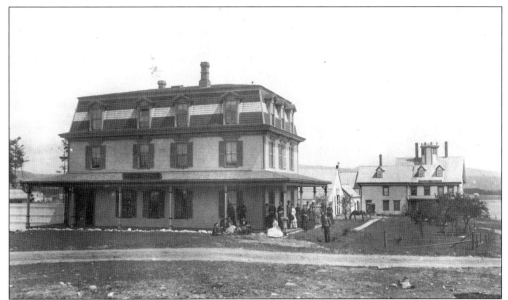

As the Ocean House gained in popularity as a summer retreat, Nathaniel Teague built an annex called Ocean Cottage. Ocean Cottage, with its mansard roof, is seen in the foreground; the rear of the original hotel is in the background. Between the two buildings is a stable that provided guests with horses and carriages for scenic drives around Mount Desert. (Courtesy of MHPC.)

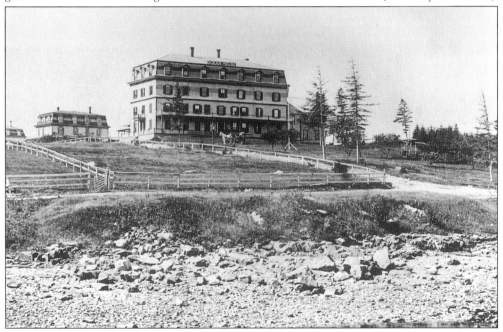

Between 1885 and 1886, Nathaniel Teague enlarged the Ocean House by adding two bays on either side, as well as a third story and a mansard roof. By 1888, Asher Allen of Springfield, Massachusetts, had acquired the Ocean House and Ocean Cottage, left, both of which he operated for a few years before selling the cottage and retaining the hotel. On June 15, 1895, the *Bar Harbor Record* praised the Ocean House as "one of the oldest and best hotels." (Courtesy of Ed Wheaton.)

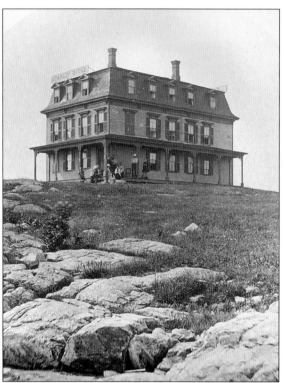

On the south side of Southwest Harbor, mariner Sans Stanley built this hotel in 1876. Located in the Manset section of the town, the Stanley House had a commanding view of the harbor. The Stanley was a particular favorite with Boston area academics and their families. (Courtesy of MHPC.)

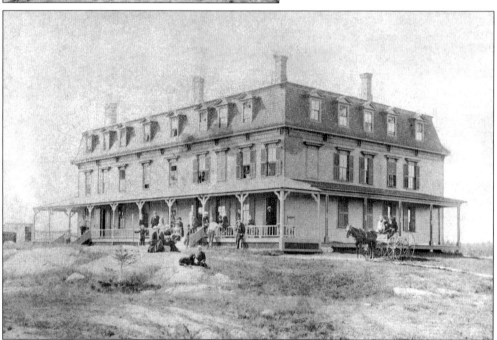

The popularity of the Stanley House quickly led to its enlargement. This view shows the original hotel at the right with a five-bay addition at the left. The bracketed veranda, a favorite congregating spot for guests, was extended along the first story of the new section. (Courtesy of SWHL.)

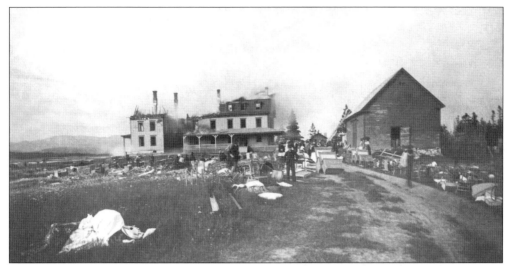

The large wooden summer hotels of the Maine coast frequently fell victim to fire, and the Stanley House was no exception. This poignant scene shows the aftermath of a July 10, 1884 fire, which destroyed much of the mansard roof and rendered the building a loss. Because the fire occurred in season, guests' possessions are mixed with hotel furnishings in the piles of what could be rescued from the flames. (Courtesy of SWHL.)

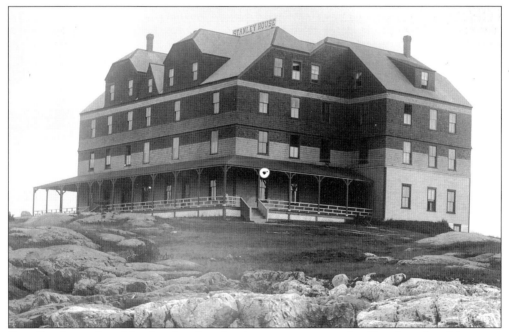

Sans Stanley replaced his first hotel with a larger structure in the Shingle style of the time. Between 1885 and 1886 the Rockland contractor William H. Glover erected what M.F. Sweetser described in *Chisholm's Mount Desert Guide Book* as "the tall modern building of the Stanley House, a favorite and delightful resort of college professors and their families." In 1894, Stanley passed the operation of the hotel to his daughter-in-law Mrs. E. Benson Stanley, who opened the Stanley House each season until it too burned in March 1927 after being struck by lightning. (Courtesy of Ed Wheaton.)

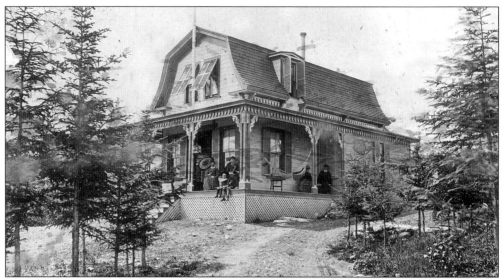

In 1868, the Boston merchant Alpheus Hardy built the first summer cottage in Bar Harbor. Almost 15 years later, W.P. Dickey and Col. Augustus B. Farnham of Bangor constructed the first cottages in Southwest Harbor. Shown here in an 1884 photograph, the Dickey Cottage was similar to the modest but decorative Victorian cottages fabricated in Bangor lumbermills and shipped by vessel to the Methodist campground in Northport near Belfast. This narrow dwelling featured a gable-ended mansard roof and a bracketed wraparound porch. (Courtesy of MHPC.)

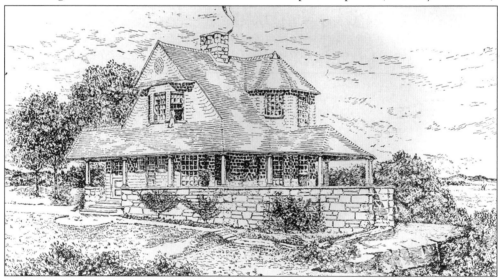

One of Southwest Harbor's first Shingle-style cottages was built by Prof. and Mrs. Samuel M. Downs of Andover, Massachusetts. Constructed in 1885–1887 from designs by the New York architect William A. Bates, the home, known as Edgecliff, is depicted in this rendering, which appeared in the March 23, 1889 issue of *Building*. The *Mount Desert Herald* of July 8, 1887, eloquently stated that the owners and their architect "have so considered the surroundings, that the house with its curving octagonal piazzas, its orial windows and its paint like the firs and spruces in color, seems as much a growth as the boulders and ledges which encompass it." Annie Sawyer Downs was the founder of the local library and a writer who contributed to Edward Rand's *Flora of Mount Desert*. (Courtesy of MHPC.)

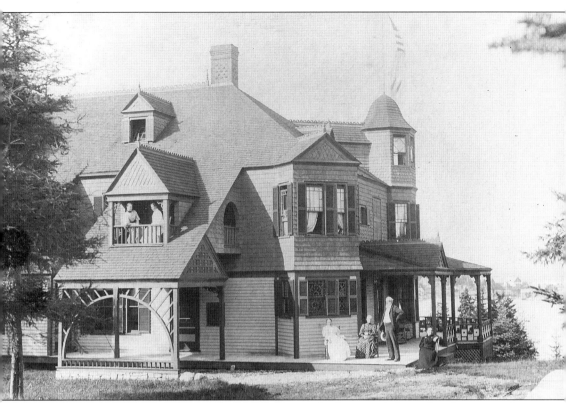

By the late 1880s Southwest Harbor's summer cottages had assumed the scale of year-round homes. In 1888, Drs. Alexander and Abby Fulton of Ellsworth built this elaborate Queen Anne residence, initially known as Highland Cottage. Located on the Manset side of the harbor, Fulton's house was constructed by P.H. Stratton, an Ellsworth builder, using a design from the July 1887 *Scientific American Builder's Monthly*. Highland Cottage's entertaining rooms, reception hall, parlor, den, and dining room were often used in the early 1900s for temperance meetings. Both Abby Fulton and her husband, Alexander, were prominent physicians in Ellsworth, she being the city's first female doctor. Trained in Boston, London, and Paris, she returned to Ellsworth to specialize in women's and children's diseases. By the 1890s, shortly after her husband's death, she began devoting her life to championing the temperance and women's suffrage movements. Fulton contributed her dynamism to these issues until her death in 1911. (Courtesy of NEHL.)

In the early 1850s, William Underwood & Company of Boston established a canning factory on Clark's Point; the company was later moved to Bass Harbor. By the 1880s, Underwood family members were summering in Southwest Harbor hotels and, in 1901–1902, William L. Underwood built the large Shingle-style cottage near Edgecliff. Known as Squirrelhurst, the cottage was designed by Lois Lilley Howe, a graduate of the Massachusetts Institute of Technology and one of America's first female architects. The contractors were Clark and Manchester of Northeast Harbor and Norris of Ellsworth. Here, comfortable rockers and Windsor chairs grace Squirrelhurst's broad veranda. (Courtesy of SWHL.)

By the early 20th century, European-inspired eclecticism was playing an important role in the summer architecture of Mount Desert. Nowhere was this more apparent than in the romantic Swiss chalet on Fernald Point that Robie M. Norwood built in 1916–1917 for Frances Scott's retirement. Surprised by the construction costs, Scott opened her 26-room cottage, Grand Pre, as a teahouse for a few years, recouping the unanticipated additional expense. Initially she used the smaller bungalow on the right as a guesthouse and later as her retirement home. (Courtesy of MHPC.)

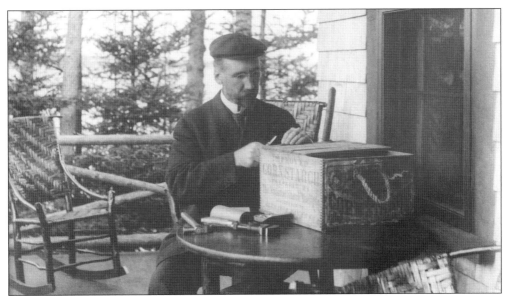

Henry Rand's self-portrait illuminates his character perfectly. Taken in 1908 on the porch of his beloved rustic cottage Fox Dens, Rand is shown meticulously mending his fishing box, preparing for another island excursion. An early visitor to the island, he chose the simple lifestyle of Southwest Harbor and, in 1900, built his cottage on the back shore of Clark Point. Although he was an accountant by profession, his talent for capturing on film the people and natural beauty of Mount Desert Island is evident in the images he left behind. The island lured him and his wife to settle there permanently in the 1930s. (Courtesy of SWHL.)

This newspaper description may have attracted Henry Rand and his friends to travel by buckboard to explore High Head, located just north of Pretty Marsh: "This high and beautiful spot, with its picturesque scenery suggestive of Scottish Highlands, may some day in the near future become as famous as Bar Harbor. The harbor is surrounded by high land from which a view of the beautiful bays . . . seen on a bright summer's day can never be forgotten." (BHR, May 17, 1888; courtesy of SWHL.)

Mrs. Burton Harrison could not have described this scene better: "Beech Hill is a place where you climb up a rocky stairway to reach a summit, whence, looking down, you behold the greater part of the beautiful island stretched in a green map at your feet, cleft by the silver fiord of Somes Sound, and adorned by many a sparkling lake-gem. Here, sitting on beds of juniper . . . you may, if you have nerve enough, look down a sheer precipice of granite hundreds of feet into the silent shadows of Echo Lake beneath." (M.F. Sweetser, *Chisholm's Mount Desert Guide Book*; photograph by George Neal; courtesy of SWHL.)

Great Long Pond, sandwiched between the cliffs of Western Mountain to the west and Beech Mountain to the east, was a frequent excursion destination. The sandy shores on the southern end of the four-mile lake made a perfect place for picnics, or in this case, enjoying the landscape and washing off the carriages. The horse pulling the elegant Stanhope-style "top buggy" must have enjoyed the rest as well; his hooves are soaking in Maine's cool waters. (Courtesy of MHPC.)

Three
NORTHEAST HARBOR

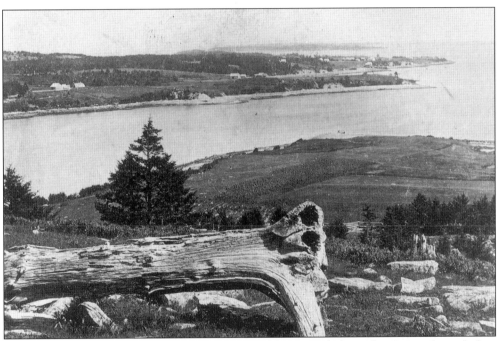

From the peak of Flying Mountain, with Fernald's Point below, the peninsula including Northeast Harbor is in full view across Somes Sound. At the time of this 1870s photograph, 17 modest homesteads lay scattered in this locality, owned by the Corson, Manchester, Whitmore, Fennelly, Gilpatrick Kimball, and Smallidge families. Intermarriages among these families would keep these names prominent in this area throughout the next century. They had settled an area known for its scenic glory, as Clara Barnes Martin wrote in 1874, "Of all the little bays and coves of this nook-shotten isle, none is fairer than this, with the smooth green fields and shaded slopes around it." Summer people, drawn by these attributes and the hardy independent nature of the island's residents, soon bought islander's homes and built their own. By the 1920s, 175 cottages were interspersed among the native homesteads. (Clara Barnes Martin, page 75; courtesy of MHPC.)

Maj. John Manchester built his Cape-style house near the shore of Manchester's Point *c.* 1820. During the 1880s, his son Ansel L. Manchester moved the "Old Homestead" to its present location on Manchester Road and constructed the large building to the right. An 1887 newspaper reported that Manchester had rented the old house for the summer and was living at Indian Head, his new hotel on the Point. (Courtesy of NEHL.)

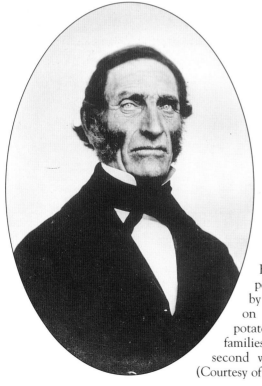

John Manchester III (1795–1870), known as Major from his Maine Militia service, was the grandson of his namesake, who settled on Manchester Point *c.* 1775. Family lore tells of the settler's endurance in surviving a winter in late 1770s in a cabin left bare by British troops, who destroyed all their possessions. The Manchesters persevered and, by the 1840s, had amassed more than 410 acres, on which they produced enough wheat, oats, potatoes, beans, and peas to provide for their large families. Major had 13 children by his first and second wives, Linda Clement and Salome Frye. (Courtesy of Connie Seavey.)

Jonas Corson moved across the sound to this plot on the eastern shore of Northeast Harbor (then called Sandy Point) in the 1830s. His son Capt. Joseph Corson retired from the sea in the 1880s and added the wraparound piazza to his simple vernacular farmhouse, the Corson Homestead, in 1887. Unfortunately, Corson was so busy that he had little time to enjoy its splendid view across Somes Sound. Partnering with Charles Frazier, they purchased buckboards and opened a livery service, driving summer folks on excursions and islanders on errands to neighboring villages. Corson had two horses that were particularly famous for being able to out-pace any other local horse. In addition to the livery service, Corson worked on building and straightening local roads, which in many cases required blasting through hard granite. (Courtesy of NEHL.)

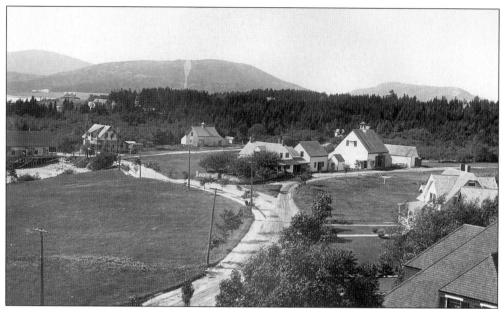

Taken from the Rock End Hotel at the turn of the century, this photograph provides a rare glimpse of the rural life of Northeast Harbor, which coexisted with the summer colony during its first decades. At the far left is Arthur Gilpatrick's store and farm, and in the center the Samuel N. Gilpatrick homestead, with its barn and outbuildings. At the far right is the roof of one of the Herman Savage's Rock End Hotel cottages. (Courtesy of NEHL.)

One of Northeast Harbor's oldest houses is this modest Cape, which Samuel N. Gilpatrick built in the 1820s. From 1875 to 1882, Mrs. Gilpatrick operated the town post office in her kitchen, and later the house became a seasonal restaurant called the Tea Garden. In 1930, David Luke Hopkins converted the Gilpatrick homestead into a summer residence known as Little Orchard with the assistance of the Boston architectural firm of Little & Russell. (Courtesy of NEHL.)

78

In this *c.* 1906 image, Julia Kittredge Gilpatrick, "Gram," is surrounded by her six grandchildren, offspring of her children Arthur, Julia Savage, Abram, Georgia Tracy, and Cora Hamor. Gram and her husband, Samuel N. Gilpatrick, spent their married lives in Northeast Harbor. When her husband was away at sea fishing, Gram tended their farm and cared for the children. Upon his return, she helped him smoke and salt the fish he had caught. Her duties expanded when, in 1875, she was appointed postmaster for Northeast Harbor; she operated the post office out of two drawers in her kitchen. (Courtesy of NEHL.)

For many years, Stephen Smallidge, seated at center, worked as lighthouse keeper at nearby Bear Island. Just before resigning in 1882, Smallidge added a second story to his homestead in preparation for its summer rental. He and his wife, Catherine (Kimball), had four daughters, who are, from left to right, Augusta, Ida, Adelma, and Sarah. They also had a son Fred. The income from summer rentals, later supplemented by Smallidge's small salary as postmaster, helped provide for this large family. (Courtesy of Lucy Smith.)

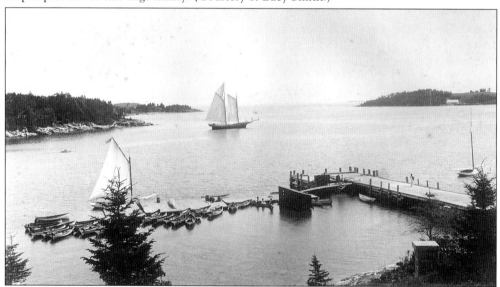

In the 1860s, Northeast Harbor residents made their living chiefly from fishing and farming. Coasters similar to the one pictured were a frequent sight here, as they came in to provision their boats at Squire Kimball's general store, uphill from this wharf. Between the 1820s and 1870s, this merchant offered the only supplies between Somesville and Long Pond (Seal Harbor). As the summer trade blossomed, natives Charles Spurling and Capt. Lewis Ladd offered a collection of rowboats and sailboats for rent from this dock, a short walk from the Clifton House Hotel. (Courtesy of MHPC.)

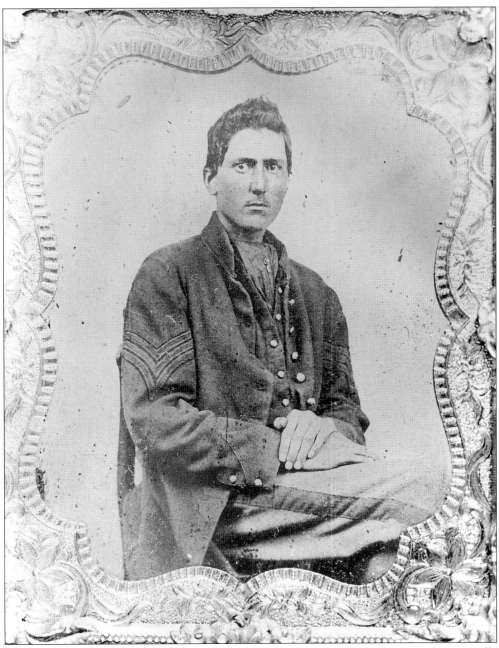

On April 15, 1861, Pres. Abraham Lincoln issued the first call to duty by state militia. Locally organized soldiers such as Samuel T. Savage eagerly signed on for the 90-day enlistment, although they had no experience or combat training. Pay was poor, but each incremental increase was gladly accepted, as Savage wrote to his sister-in-law in February 1864: "I am Orderly Sergt . . . now, they put the diamond on me the 20th of this month, so I get 20 dollars per month now. Thats a little better than 13." Just a year later, after returning home to the island, Savage died from wounds. By the Civil War's end, the town of Mount Desert could count 81 men who served, eight of whom were substitutes. At least 26 of these men were killed or died while in service. (Courtesy of Rick Savage.)

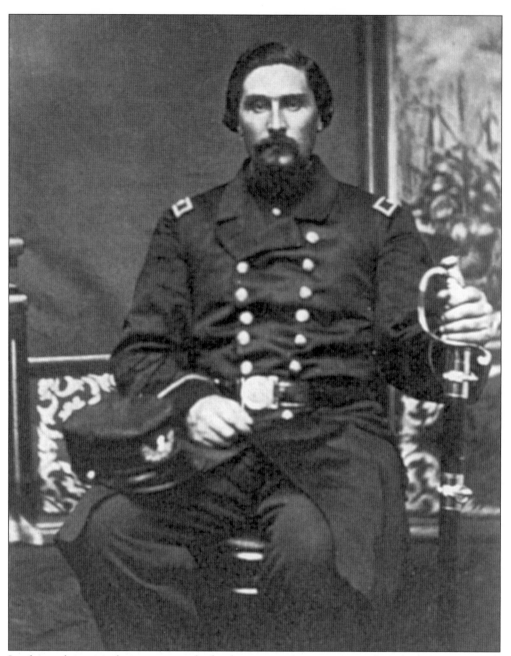

In the end, some of our veterans had taken part in every aspect that this war presented, including horrid battles, the wounding and killing of family and friends, and sickness and disease. They suffered from low pay, bad food, military routine, and worry about the welfare of their families. In writing to his wife, Augustus C. Savage, acting lieutenant in the U.S. Navy, reported: "I was on shore at the hospital with the Drs. to see them manoover in the taking off legs and arms, etc. The wounded man is brot in on a stretcher & laid down & is put under the influence of either . . . the Dr. goes in & cuts away as carelessly as I would a leg of mutton . . . douces on some cold water on the wound also on the patients face and sings out to him to wake up." (Courtesy of Don Phillips and Rose Ruze.)

The steamer *Rangeley* was built for the Maine Central Railroad in Bath in 1913 to carry passengers from the mainland rail terminus of Mount Desert Ferry to the resort towns on the island. Here the *Rangeley* is shown leaving the steamboat dock at Northeast Harbor. Growing competition from the automobile ended the *Rangeley*'s run in Maine waters in 1925, and she became a Hudson River Day Liner known as the *Chauncey M. Depew.* (Courtesy of NEHL.)

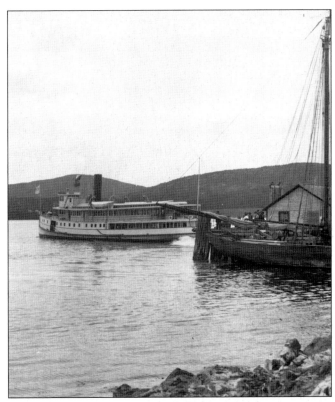

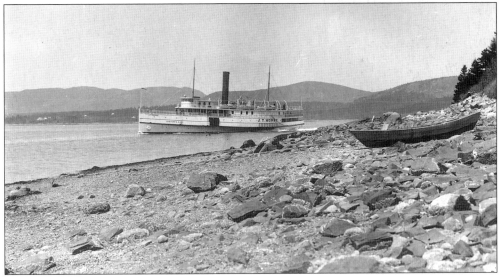

From 1903 to 1933, the Eastern Steamship Company's *J.T. Morse* made the daily run to Mount Desert from Rockland, where the steamer connected with the railroad to take on passengers. William W. Vaughan wrote glowingly of the ship, shown here rounding Smallidge Point in Northeast Harbor: "The wily traveler from Boston, who fears a sleep-banishing serenade of fog whistles, takes the afternoon train to Rockland, goes peacefully to bed in one of these staterooms, and lands without a shade of the weariness of his seagoing brother who sailed from Boston." (Courtesy of NEHL.)

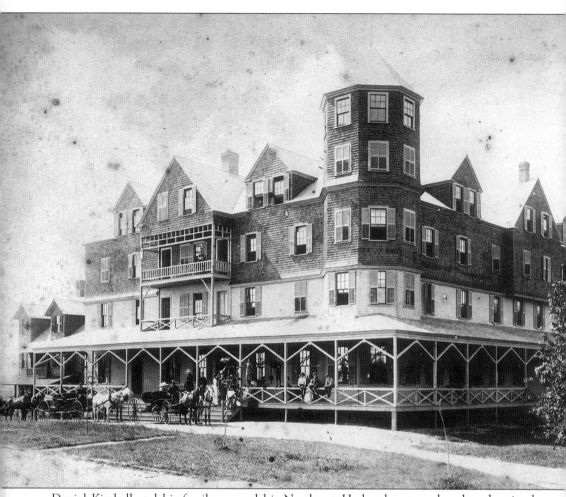

Daniel Kimball and his family opened his Northeast Harbor homestead to boarders in the 1830s. Shortly before his death in 1887 at the age of 85, he and his son Loren replaced their modest inn on Cottage Street with a large Queen Anne–style hotel designed by John E. Clark of Bar Harbor. Built in 1886–1887, the Kimball House featured a wraparound piazza and an octagonal corner tower. The first floor was devoted to a parlor, a music hall, and a dining room; the upper floors contained 70 guest rooms. For decades the Kimball House was a mainstay for Northeast Harbor until its closing and demolition in 1966. (Courtesy of the Kimball family.)

Loren E. Kimball (1855–1931), a younger son of Squire Daniel (probably the subject of the wall portrait) and his wife, Emma (Gilpatrick), became the patriarch of his family after his father's death. Although he was best known as the proprietor of the Kimball House, he actively nurtured other aspects of the resort's development. Besides helping his four siblings build cottages for summer rental, Loren was instrumental in erecting the local steamboat wharf, creating an elegant serpentine road to open up lots on Schoolhouse Hill, and establishing a store downtown in 1897. By 1894, the local paper acknowledged that "Northeast Harbor today is what Bar Harbor was ten years ago. A hop at the Kimball's or Rock End is like the old Rodick House hops that have gone down to history." (BHR, May 17, 1894.) These successes allowed Loren and his wife, Cora (Conners), to escape to the warmer climate of Florida each winter. (Courtesy of the Kimball family.)

In 1888, M.F. Sweetser described Asticou Village as "a charming sequestered neighborhood haunted through the lifelong summer by bright tennis-suits and vivacious exiles from the cities." Asticou's elevated location at the head of Northeast Harbor made it an ideal location for summer hotels and cottages, as seen in this late-19th-century view. At the left is the Roberts

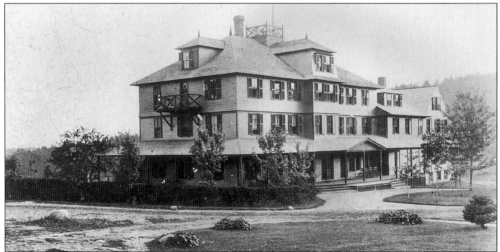

Following the Civil War, Augustus C. Savage sailed vessels out of Northeast Harbor, while his wife, Emily Manchester Savage, took in summer boarders at their home in the Asticou neighborhood. Upon retiring from the sea, Savage became a contractor and a hotel owner, building the first Asticou Inn in 1883 from designs by his architect son Fred L. Savage. This pleasant Shingle-style inn was a favorite with summer visitors until its destruction by fire in September 1900. (Courtesy of Rick Savage.)

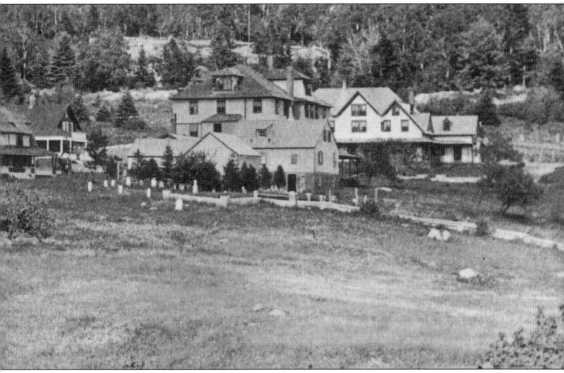

House; in the center, the gambrel-roofed home of architect Fred L. Savage; and at the right, Augustus C. Savage's first Asticou Inn, with his gabled Harbor Cottage beyond. The Savage family shaped Asticou with their hotel, cottages, and homes. (Courtesy of Rick Savage.)

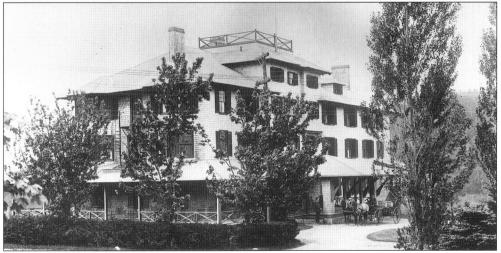

Augustus C. Savage wasted no time in building the second Asticou Inn on the site of the first. Between the fall of 1900 and the spring of 1901, a more spacious Shingle-style inn rose at the same location, again from the designs of Savage's son Fred, by then a major Bar Harbor architect. At nearly 70 years old, Augustus Savage delegated the operation of the new hotel to his son George, who became its proprietor after his father's death in 1911. Now entering its second century, the Asticou Inn is the last of Northeast Harbor's noted summer hotels. (Courtesy of NEHL.)

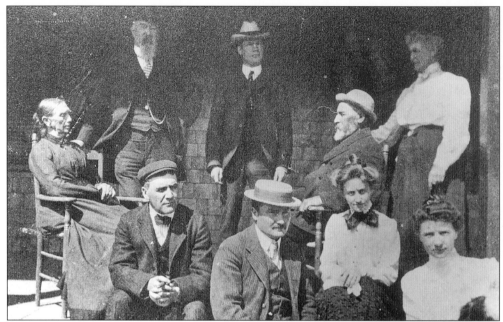

Running the Asticou Inn and its associated cottages took all the efforts of the Savage clan, shown relaxing with friends. The original proprietors, Augustus C. and his wife, Emily Manchester (facing each other), depended on the help of their six children to manage the Asticou and related properties. Annie and Cora (seated at right) and George (not shown) assumed responsibilities for the daily operations. John (not shown) ran the nearby grocery store and provided the hotel with dairy products from his farm. Sons Herman and Fred (front left) contributed whenever possible, but were busy with their own respective businesses, the Rock End Hotel and an architectural firm. (Courtesy of Rick Savage.)

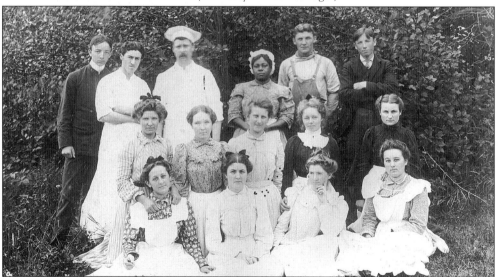

Lacking modern labor-saving devices, the Savages hired help from their extended family, neighboring villages, and even Boston to open, manage, and close the Asticou Hotel annually. This staff portrait features pastry chef Mary Carr (center, back row), who discovered the hotel fire "racing up the walls." (Courtesy of Connie Seavey.)

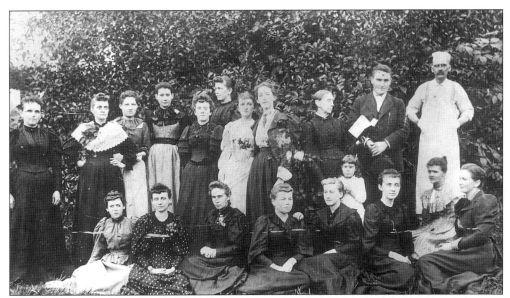

In this *c.* 1895 image, waitresses in long black dresses and other Asticou staff members pose with George Savage, who is standing next to his mother, Emily Manchester Savage. This seemingly austere matriarch, preoccupied with her book, oversaw all operations of the Asticou and in the process won praise from her family and staff for being "ready to do whatever lay in her power to alleviate any suffering, either mental or physical, that came under her observation. She was purely unselfish." (Manchester paper, NEHL, page 8; courtesy of Rick Savage.)

Born in Northeast Harbor, Augustus Chase Savage (1831–1911) was an enterprising Yankee who made the transition from a maritime to a summer-based economy. Savage's early life was spent at sea, and he served in the navy during the Civil War. While he continued to sail vessels after the war, Savage and his wife, Emily, became increasingly involved in tourism, renting rooms in their home and then building the first Asticou Inn in 1883, to be replaced by the present one in 1900. Two of their four sons, Herman and George, also pursued the hotel business, while another son, Fred, became Mount Desert's leading summer cottage architect. (Courtesy of Rick Savage.)

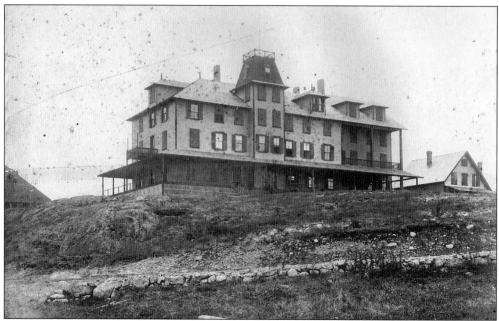

A promotional brochure described the Rock End Hotel as "conveniently situated, overlooking the waters of the bay and Somes Sound, built on a bluff which affords an excellent view in all directions." On this commanding site in 1883–1884, Augustus C. Savage's son Herman L. Savage built a three-story hip-roofed hotel, which featured a four-story mansard tower. Originally called the Revere House, the hotel soon became known as the Rock End. (Courtesy of MHPC.)

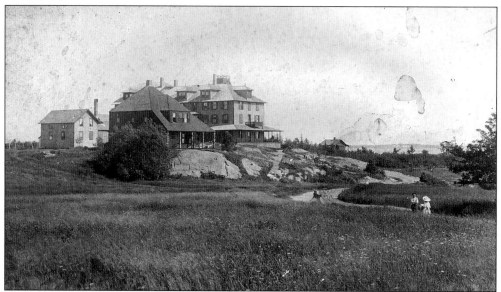

This early photograph of the Rock End dramatically illustrates a period description that "the hotel grounds are extensive, with nothing to obstruct the view or mar the natural landscape." In the foreground is proprietor Herman L. Savage's residence of 1885–1886, which his brother Fred designed for him. Savage made this eight-room Shingle-style cottage available for rental to hotel guests during the summer season. (Courtesy of the Great Harbor Collection.)

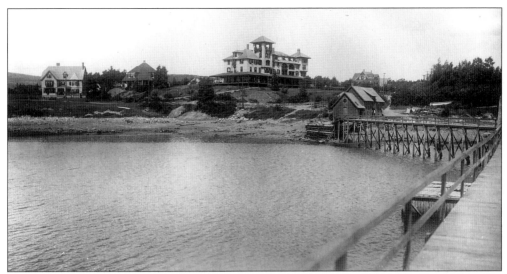

Herman L. Savage spent his winters managing hotels in Florida. Probably influenced by the architecture of southern resort hotels, Savage had his brother Fred transform the Rock End in 1894 from a clapboarded Victorian to a stuccoed Spanish Revival structure complete with an open hip-roofed tower, echoed by a lower corner tower. The remodeled Rock End boasted "accommodations for about one hundred guests, long distance telephones, electric lights, sanitary plumbing, private baths." (Courtesy of NEHL.)

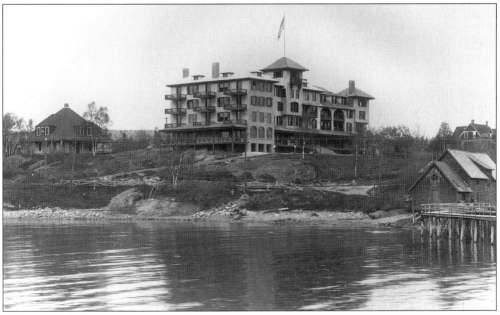

In 1909, Herman L. Savage turned to his brother Fred to design a four-story stuccoed addition to the water side of the Rock End. This final expansion enlarged the hotel's capacity and added a dining room that could seat 300. After Herman Savage's death in 1913, his family operated the Rock End until it burned on March 4, 1942. Local resident Billie Favour recalled the hotel with "its balconies rimmed with flowering windowboxes, and its lawns by day whirring with hand mowers, or the strains of its evening dance orchestras drifting out over the waters of the cove." (Courtesy of NEHL.)

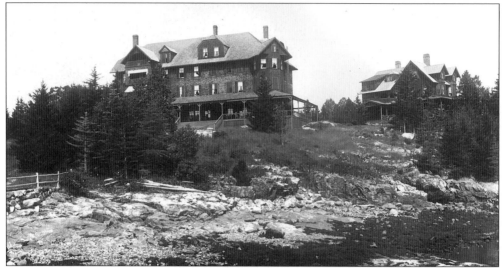

Located near the mouth of the harbor, the Clifton House was built in 1885–1886 by Clarence A. Kimball near the site of his father Daniel Kimball's chandlery store. This three-story, 30-room Shingle-style hotel was designed by John E. Clark of Bar Harbor and constructed by the local contractor James H. Soulis. Johns Hopkins University Pres. Daniel Coit Gilman and his family were among the first season's guests. In 1892, Clark designed the large cottage at the right for Kimball's own use. The Clifton was a Northeast Harbor landmark until its demise in 1939. (Courtesy of NEHL.)

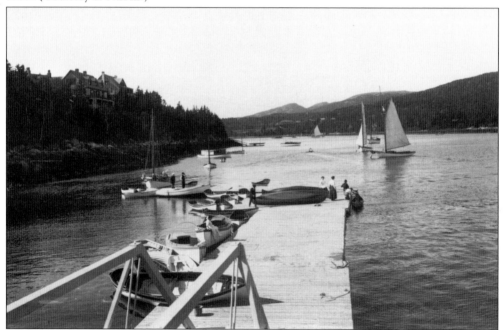

Looking toward the head of the harbor, this early-20th-century view of the Clifton House dock underscores the favorable location that the hotel enjoyed. As M.F. Sweetser commented in 1888, "the Clifton House rises on the high bluff over the old steamboat wharf, close to the mouth of the harbor, and looking well out to sea, and down on the landing stages, where dozens of pleasure-boats are kept." (Courtesy of NEHL.)

Born in Boston, Joseph Henry Curtis (1841–1928) began practicing landscape gardening in the early 1870s. In Maine, his work included planning coastal summer colonies and the grounds of Bar Harbor cottages. Curtis became a pioneer of the Northeast Harbor summer community in 1880 by acquiring land at Asticou, where he built a rustic cabin that year and a cottage in 1897. Surrounding these homes, Curtis created Asticou Terraces, a 215-acre park of paths and shelters that he gave to the Town of Mount Desert. (Courtesy of NEHL.)

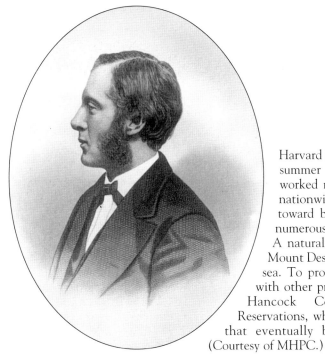

Harvard Pres. Charles Eliot, one of the first summer cottagers in Northeast Harbor, worked resolutely for educational reforms nationwide. He applied this same energy toward building a Union Church and to numerous other local civic improvements. A naturalist, Eliot never tired of exploring Mount Desert Island's woods, mountains, and sea. To protect these resources, Eliot joined with other preservation advocates to form the Hancock County Trustees for Public Reservations, which privately purchased the land that eventually became Acadia National Park. (Courtesy of MHPC.)

In the summer of 1880, Charles Eliot, the son of the Harvard president, led seven college friends on a scientific expedition to Mount Desert. Calling themselves the Champlain Society, after the French explorer, the group camped on the eastern shore of Somes Sound to study geology, ornithology, marine invertebrates, meteorology, botany, entomology, ichthyology, and photography. Shown from left to right are Orrin Donnell, Charles Eliot, Heylinger DeWindt, Charles Townsend, Samuel Eliot, William Davis, ? Wakefield, Edward Rand, and their steward William Bryant. Charles Eliot became a noted Boston landscape architect who worked with Frederick Law Olmsted. (Courtesy of Nan Lincoln.)

The Champlain Society's Camp Champlain consisted of tents pitched on the eastern shore of Somes Sound during the summers of 1880 and 1881. In 1882, the society moved to the head of Northeast Harbor near Augustus C. Savage's house, remaining there for two seasons. The society's scientific investigations resulted in two publications, *Outline of the Geology of Mount Desert,* by William M. Davis, and *Flora of Mount Desert,* by Edward L. Rand. (Courtesy of MHPC.)

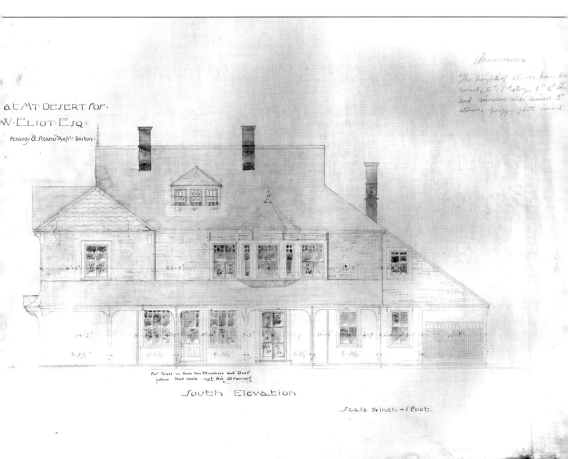

at MT·DESERT for·
W·ELIOT·ESQ·

Peabody & Stearns Arht·· Boston·

For Glass in these two Windows and Door
follow Inch Scale. not this Drawing.

South Elevation

Scale ¼ inch = 1 Foot.

After camping at Northeast Harbor with the Champlain Society in 1880, Charles Eliot told his father to build a summer home between Somes Sound and Seal Harbor. The elder Eliot and his wife explored the east shore and purchased a 100-acre lot, upon which they constructed their cottage in 1881 from designs by Peabody & Stearns of Boston for $6,840. As one of Northeast Harbor's first cottages, the simple rustic character of Blueberry Ledge, the Eliots' new home, set the tone for much of the community's summer architecture. (Courtesy of MHPC.)

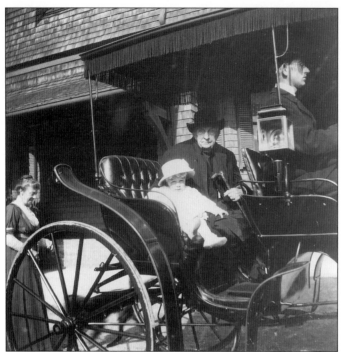

William Croswell Doane (1832–1913), bishop of Albany, known for his classic British attire, readies for a carriage ride with his granddaughter. As Doane summered in Northeast Harbor, so too did his extended clan and Albany friends, such as Mr. and Mrs. Erastus Corning. The Sunday evening vespers held on the ledges outside his house and a midsummer Christmas tree became community traditions, memorializing his influence by setting a high moral tone for summer and permanent residents. (Courtesy of NEHL.)

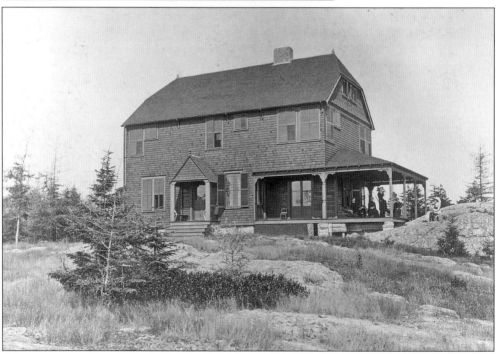

After staying at Daniel Kimball's inn during August 1880, Bishop Doane purchased land on South Shore Road that year for a cottage. Built in the spring of 1881 and occupied that summer, the home known as Magnum Donum, like the Curtis and Eliot cottages, was one of Northeast Harbor's first summer residences. This early photograph shows Doane's house before the addition of roof dormers and a corner tower. (Courtesy of NEHL.)

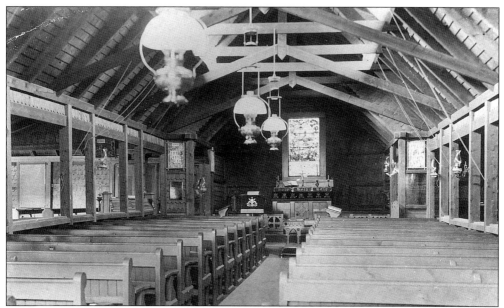

During the summer of 1881, Bishop William C. Doane of Albany held Episcopal services in the hall of his new cottage. At the end of August, his congregation resolved to build a summer chapel for the next season. The project was made possible by donated land, a major bequest of funds, and the gift of plans by the Boston architect George Moffette. St. Mary's-by-the-Sea, consecrated on August 20, 1882, featured this simple open sanctuary with exposed framing. (Courtesy of NEHL.)

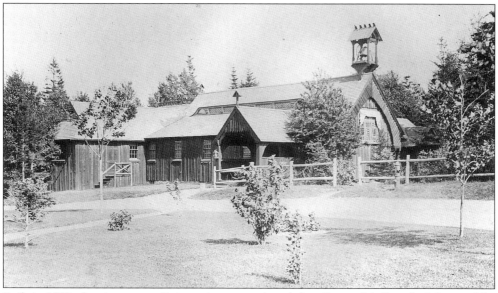

Built in 1882, the picturesque Episcopal summer chapel that George Moffette had designed for St. Mary's-by-the-Sea attracted so many worshipers that the building was twice enlarged. A south aisle and west porch were added in 1886 and a north aisle and transept in 1887. This increased the building's seating capacity to 400. *North East*, a Maine Episcopalian magazine, described St. Mary's-by-the-Sea in 1889 as "a beautiful specimen of rustic architecture. It is covered with rough spruce slabs." (Courtesy of MHPC.)

Twenty years after Bishop William C. Doane opened the first St. Mary's-by-the-Sea, Bishop Robert Codman of Maine, in conjunction with Bishop Doane, consecrated the second, more permanent church on August 24, 1902. The poor condition and inadequate size of the rustic summer chapel convinced the congregation to commission the noted ecclesiastical architect Henry Vaughan of Boston to design this beautiful stone and half-timbered Gothic Revival church, which was built by the local contractor J. H. Soulis over a two-year period for $35,000. (Courtesy of NEHL.)

Designed by the noted Boston architectural firm of Peabody & Stearns, the Union Church of 1887 is a striking Shingle-style building. Its low stone walls and expansive wood-shingled roof convey the organic relationship between building and site that are the essential characteristics of the style. Northeast Harbor summer resident Charles W. Eliot headed the building committee, which undoubtedly influenced the selection of Peabody & Stearns, who had planned the Harvard president's cottage. The church was dedicated in 1889, and the transept was added in 1913 by the original architects. (Courtesy of MHPC.)

Maine summer colonies frequently built Catholic churches to accommodate the staff members of the hotels and cottages. In Northeast Harbor, Catholics held services in the Union Church for six years before constructing St. Ignatius, a picturesque shingled church designed in 1895 by Fred L. Savage and Milton W. Stratton. The building's original capacity of 170 was expanded to 500 in 1901–1902 from plans by the Boston architect Edwin H. Denby. (Courtesy of NEHL.)

Fred L. Savage was the predominant architect for Northeast Harbor's buildings and James H. Soulis (1842–1918), the prevalent local contractor. Soulis' mark lies on most of the local public buildings and numerous cottages. In his early days in Maine, he commuted between Gloucester, Massachusetts, and Northeast Harbor, until the 1890s building boom supported his permanent residence on the island. By then, the *Bar Harbor Record* described the flourish of activity: "Each fall, when the summer visitor has fled, the big hotels closed, the sound of the hammer and saw make music in the air."(Courtesy of NEHL.)

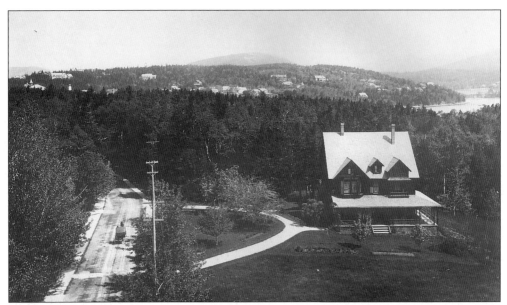

Hannah (Kimball) McBride, the eldest daughter of Squire Daniel Kimball, built this simple Shingle-style house for summer rental in 1884. The Erastus Corning family was one of her first tenants. McBride, a widower, cooked for them, preparing hardy fares with two kinds of pies for breakfast, often supplemented with fresh doughnuts, while her two young boys entertained the Corning children, taking them on tours of the woods and coves. (Courtesy of NEHL.)

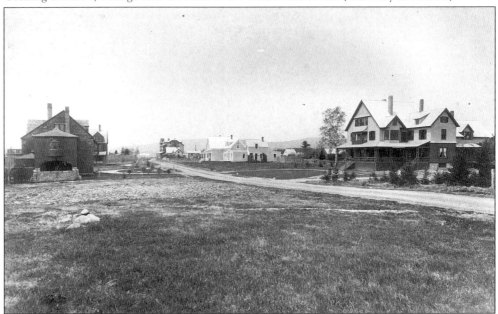

During the 1880s, Cottage Street, now South Shore Road, emerged as an important thoroughfare for the new summer resort. To the left is the Alders, the distinctive Shingle-style cottage that John E. Clark designed for S.D. Sargeant. The Rock End Hotel looms at the end of the street. The Daniel Kimball House, now Petite Plaisance, is in the center. At the right is the Homestead, a large cottage designed by John E. Clark for Daniel Kimball in 1885. (Courtesy of NEHL.)

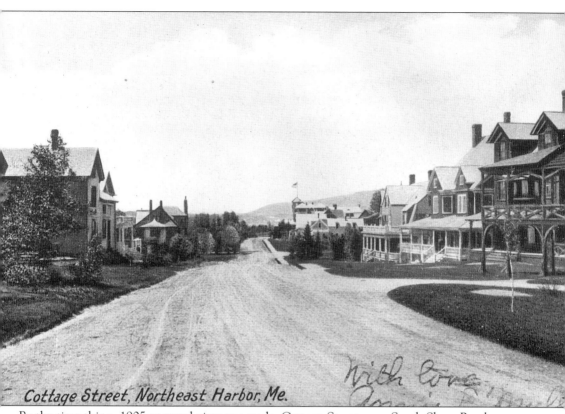

Cottage Street, Northeast Harbor, Me.

By the time this c. 1905 postcard view was made, Cottage Street, now South Shore Road, was lined with summer cottages. Halfway down on the left is S.D. Sargeant's Alders. The rustic veranda of the Kimball House hotel appears at the right, followed by Pyne Cottage, the Breezes, and Edgewood, all of which were owned by Kimball family members and associated with the hotel. (Courtesy of NEHL.)

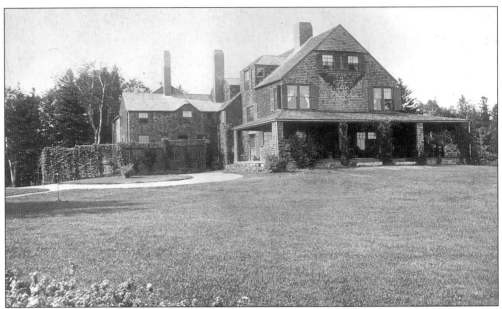

Bishop William C. Doane's son-in-law and daughter, James and Margaret Gardiner of Albany, New York, constructed Ye Haven in 1882–1883 from designs by John E. Clark of Bar Harbor. This rambling Shingle-style cottage underwent several additions over the years. A civil engineer, Gardiner planned new roads for Northeast Harbor, organized a water company, and built cottages in the Harbourside neighborhood. (Courtesy of NEHL.)

The gracious interiors of Ye Haven were a center of social life for the Northeast Harbor summer colony. This view from the stair hall shows the dining room, where the Gardiners and their four daughters frequently entertained. One of the popular events at Ye Haven was the Midsummer Tree, a party held around a large spruce on the lawn, at which the Gardiner children staged a play and distributed gifts to their guests. (Courtesy of NEHL.)

When Stuart and Colby made their map of Mount Desert in 1887, the Northeast Harbor summer colony was less than one decade old but was already well advanced in its development. This map pinpoints such summer hotels as the Asticou Inn, Harbor Cottage, and the Roberts House at the head of the harbor, as well as the Clifton House, the Kimball House, and the Rock End in the vicinity of Cottage Street (now South Shore Road). Locations are also shown for the cottages of early summer residents such as Bishop William C. Doane, James T. Gardiner, and S.D. Sargeant. (Courtesy of MHPC.)

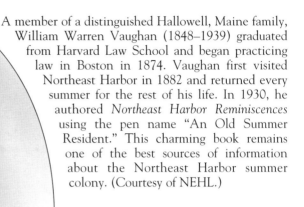

A member of a distinguished Hallowell, Maine family, William Warren Vaughan (1848–1939) graduated from Harvard Law School and began practicing law in Boston in 1874. Vaughan first visited Northeast Harbor in 1882 and returned every summer for the rest of his life. In 1930, he authored *Northeast Harbor Reminiscences* using the pen name "An Old Summer Resident." This charming book remains one of the best sources of information about the Northeast Harbor summer colony. (Courtesy of NEHL.)

In 1891, Vaughan commissioned Fred L. Savage to design a large Shingle-style cottage for a commanding site on Smallidge Point. Known as the Ledge, the Vaughan cottage was the first of several homes to be built on the point in the 1890s. (Courtesy of NEHL.)

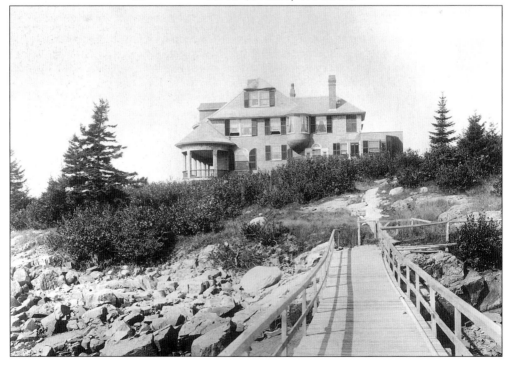

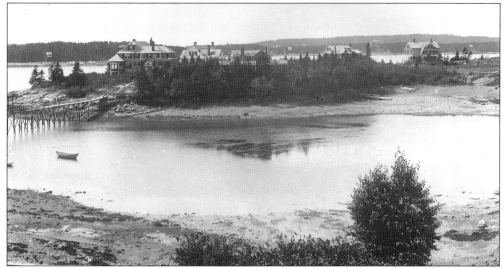

Northeast Harbor's varied topography includes several peninsulas, which lent themselves to late-19th-century cottage development. In 1891, William W. Vaughan built the first cottage on Smallidge Point, the Ledge, which appears at the left. Next door, Vaughan relatives Mr. and Mrs. Henry Parkman constructed Windward between 1893 and 1897. At the right, the gambrel-roofed cottage known as Sunset Shore was built in 1904 for Miss E.P. Sohier of Boston from designs by Fred L. Savage. (Courtesy of NEHL.)

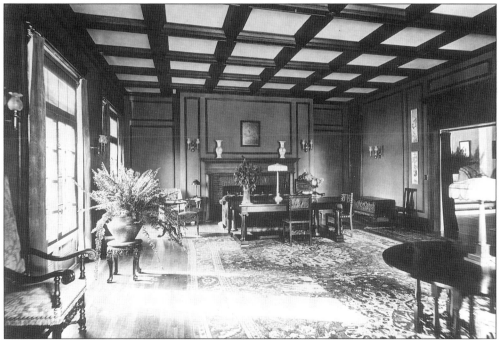

The understated elegance of the interiors at the Ledge reflects the social standing of the cottage's owners, William Warren and Ellen Twisleton Parkman Vaughan, who resided on Boston's fashionable Beacon Street during the winter months. Mrs. Vaughan came from a leading Boston family, and her paneled living room with its beamed ceiling was furnished with an oriental rug, dark furniture, and a potted fern at the window. (Courtesy of NEHL.)

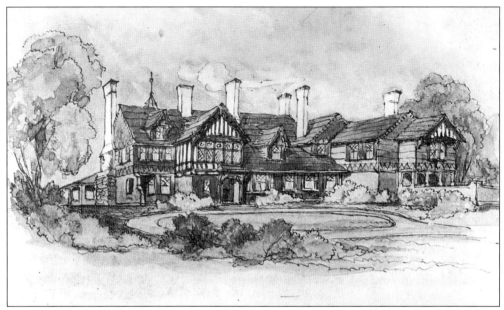

On April 15, 1903, the *Bar Harbor Record* remarked that Northeast Harbor summer residents built for consistency rather than show—with the exception of Eleanor Blodgett's newly constructed cottage on South Shore Drive. Designed by Peabody & Stearns of Boston in the English half-timbered style, Westward Way contained 35 rooms and cost its New York owner $100,000. Miss Blodgett, the daughter of William Tilden Blodgett, a 19th century entrepreneur and philanthropist, is best remembered in the village for her elaborate evening parties and furnishing the Neighborhood House in memory of her mother, Abby Blake Blodgett. (Courtesy of MHPC.)

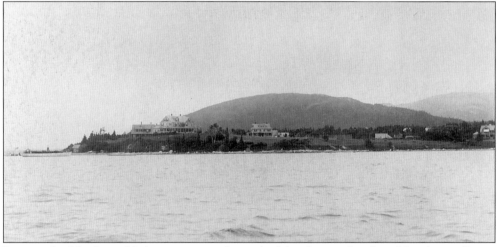

Prior to the Northeast Harbor summer colony, the Manchesters lived on Manchester Point, where they kept fish houses and smokehouses. In 1887, Ansel L. Manchester chose a prime location on the point to build Indian Head Cottage, a small summer hotel designed by Fred L. Savage. Manchester also sold adjacent lots to prospective summer colony residents. To the right of Indian Head Cottage is the Fraley Cottage of 1901, and to the far right is the Scull Cottage of 1899. The Fraleys and the Sculls were from Philadelphia and both used Fred L. Savage to plan their large Shingle-style cottages. (Courtesy of the Great Harbor Collection.)

106

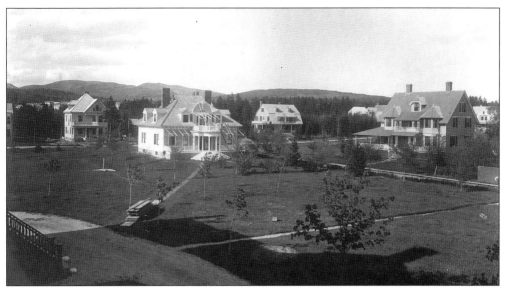

On the grounds of the Rock End Hotel, Herman L. Savage built a handsome Colonial Revival cottage in 1892 from designs by his brother Fred. Known as the Yellow House, this residence was rented to hotel guests. At the right are two more houses designed by Fred L. Savage, the Dr. J.D. Phillips Cottage of 1889 and the Falt House of c. 1895, where Herman and Fred Savage's sister Annie resided. (Courtesy of NEHL.)

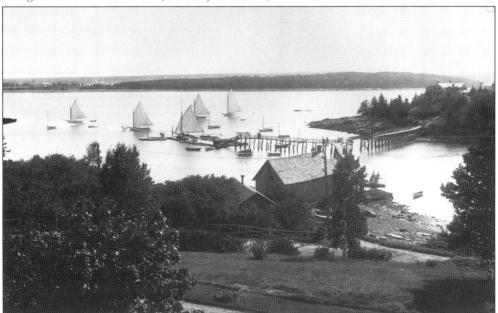

Gilpatrick's Cove was a magnet for summer activity between 1890 and 1910. Young and old could rent sloops and rowboats from Capt. Abram Gilpatrick's livery, located on the Rock End dock, seen above. Many a young skipper learned to sail at the captain's knee. Just around the bend stood Arthur Gilpatrick's well-stocked store. In the early days, islanders and rusticators congregated around its potbellied stove to discuss world affairs. Dances, recitals, and moving pictures drew young audiences to Gilpatrick's hall upstairs, until the Pastime Theater was built in the village center. (Courtesy of NEHL.)

Fred L. Savage is seated in his Bar Harbor office surrounded by renderings of his architectural projects. Born in Northeast Harbor in 1861, Fred was the second son of Augustus and Emily Savage, the enterprising proprietors of the Asticou Inn. Starting as a carpenter, he apprenticed in Peabody & Stearns' Boston architectural office from 1885 to 1887, returning to practice architecture in Northeast Harbor, where he received many commissions for summer cottages. From 1892 until his death in 1924, Savage worked in Bar Harbor, designing several hundred Mount Desert buildings during his career. (Courtesy of Rick Savage.)

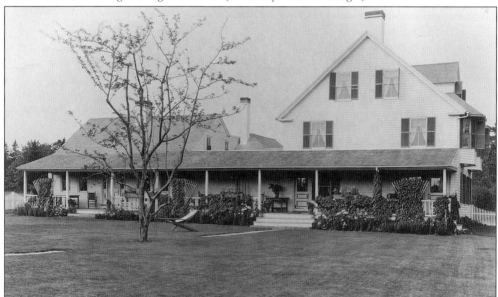

Following the nation's centennial in 1876, Americans became increasingly interested in preserving old houses. When Ansel L. Manchester began to develop Manchester Point in the 1880s, he saved his father's homestead by moving it to a new location. At the turn of the century, Manchester sold his family Cape and an adjacent building to the Pierponts, who engaged Bar Harbor architect Fred L. Savage to transform the two structures into a charming summer home by linking them with a long porch across the front. This house was later owned by the Platts.(Courtesy of NEHL.)

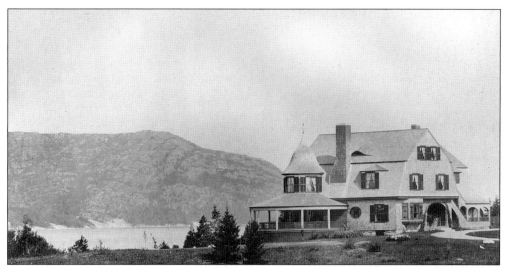

In 1890, Rev. Cornelius B. Smith purchased property overlooking Somes Sound and began constructing Rosserne, one of Fred L. Savage's finest designs for a Shingle-style summer cottage. Completed in 1891, Rosserne remained in Smith's family for more than a century. Smith served as rector of St. James Episcopal Church in New York City from 1867 to 1895. His summer services for children on the grounds of Rosserne were a Northeast Harbor tradition. (Courtesy of NEHL.)

Large summer homes continued to be built at Northeast Harbor into the early 20th century. Between 1912 and 1913, William S. Grant Jr. of Philadelphia constructed Gray Rock, a 15-room Shingle-style cottage in the Harborside neighborhood. Planned by Fred L. Savage, Gray Rock features elaborate stonework, an eclectic touch of English half-timbering on the first story, and a broad gambrel roof penetrated by many dormers to gain harbor views. (Courtesy of NEHL.)

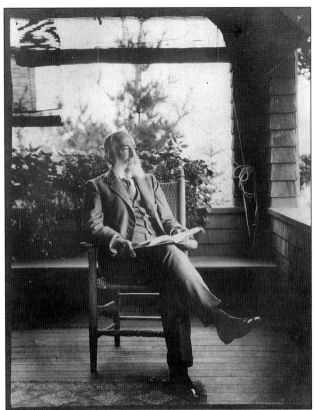

Seated on the porch of his 1895 cottage, Over-Edge, is Daniel Coit Gilman (1831–1908), Johns Hopkins University's first president. In 1885, Gilman joined the swelling number of academics in Northeast Harbor and vigorously supported the founding of the Northeast Harbor Library and later, the local high school, named in his honor. Gilman and his wife, Elisabeth (Woolsey), were popular with youngsters, entertaining them with their stories of life in Baltimore and readings from the classics. These sessions would often conclude with his niece's familiar chant, "We thank the goodness and the grace, That brought us to this lovely place, And now with all our hearts we pray, That other folks may stay away." (Courtesy of Special Collections and Archives, Johns Hopkins University.)

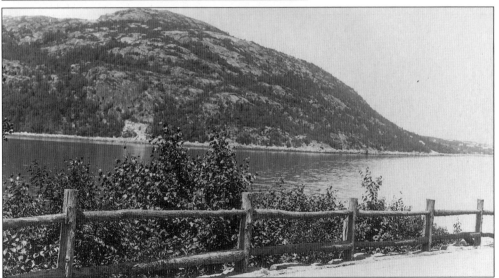

Sargeant's Drive, this scenic avenue skirting the eastern shore of Somes Sound, was named for Samuel D. Sargeant, an early summer resident whose leadership brought the project to fruition in 1901. The spelling is often confused with that of the name of islander S.D. Sargent, who originally owned this piece of land beside Somes Sound. Designed by cottager James T. Gardiner and funded with public and private funds, this was one of the first major projects of the newly established Northeast Harbor Village Improvement Society. (Courtesy of NEHL.)

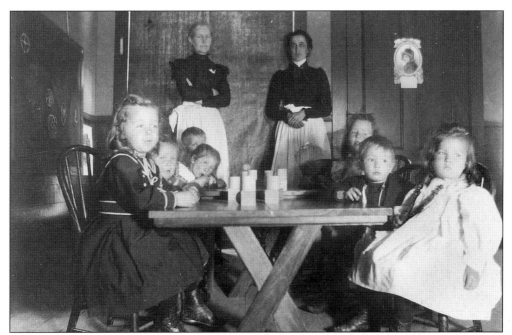

All attempts to humor these kindergartners have failed, but fortunately their attention is distracted by something in the light. In the fall of 1898, Northeast Harbor residents organized the town's first kindergarten, encouraged by summer cottager Mrs. P. Bryson. They hired Inez Smallidge and Ella Wilbur of Fall River, Massachusetts, who was noted as "a young lady of culture and refinement" by the local newspaper correspondent. Attention to parenting was not forgotten; monthly the mothers of the children would gather for instruction. (Courtesy of NEHL.)

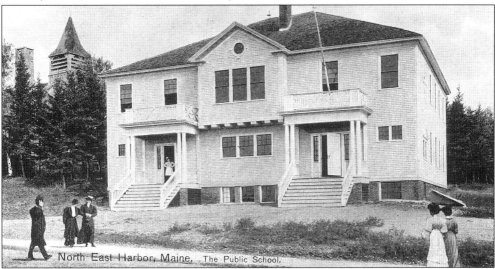

North-East Harbor, Maine. The Public School.

In 1897, Northeast Harbor replaced an 1891 school with a larger one on the same site, below the Union Church. Designed by Fred L. Savage and Milton W. Stratton, this Colonial Revival structure was enlarged in 1907 by Savage to accommodate high school students who had previously attended classes in Somesville. Named the Gilman School in honor of the noted educator and summer resident Daniel Coit Gilman, the building was used until 1951, after which it was torn down for a small park. (Courtesy of NEHL.)

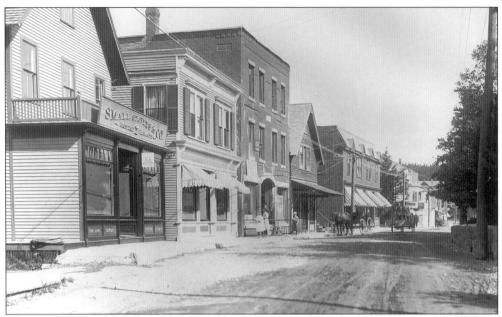

During the 1890s, Main Street developed as Northeast Harbor's commercial center in response to the summer colony's need for a variety of goods and services. By the early 1900s, attractive business blocks lined the street, including, from left to right, the Small, Staples & Company drugstore; Smith's Dry Goods; the brick Joy Block of 1901; the post office; and Kimball's Grocery Store of 1897. (Courtesy of NEHL.)

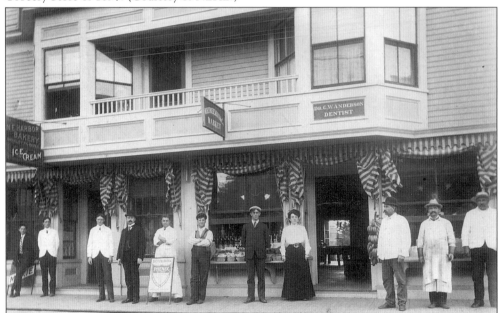

In 1897, William H. Freeman of Pretty Marsh built a large, wooden building on Main Street for his market and Shirley P. Graves' Northeast Harbor Bakery on the first floor and Dr. Anderson's dental office on the second. Just a few years later, in 1906, Merritt Ober bought the building and continued to run the market, specializing in meats, until the 1950s. He was one of three Ober families owning stores downtown. (Courtesy of NEHL.)

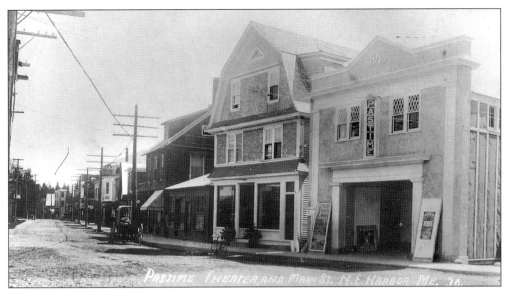

From 1913 to 1966, the Pastime Theater stood at one end of Northeast Harbor's commercial row, with its broad, welcoming entrance and attractive stuccoed facade. Designed by Fred L. Savage for Mr. and Mrs. William Dolliver, the Pastime featured movies, slides for sing-a-longs, plays, and vaudeville acts. Piano accompaniment of such famous silent films as D.W. Griffith's *Birth of a Nation* and Charlie Chaplin's *The Tramp* gave way to talking pictures in the late 1920s. With rates of 15¢ for adults and 10¢ for children, moviegoers could buy an afternoon's entertainment in one of the theater's 200 seats.(Courtesy of MHPC.)

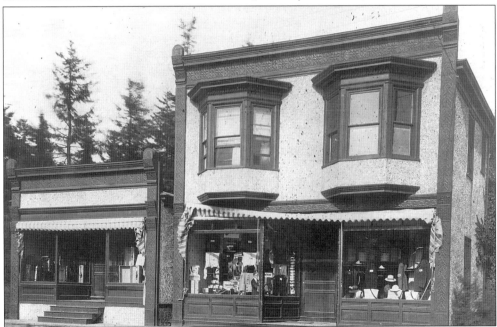

Built on the opposite side of Main Street's commercial row, the Holmes Store featured the turn-of-the-century innovation of a stucco exterior with galvanized metal trim from the George L. Mesker Company of Evansville, Indiana. Holmes operated a clothing store in his main building and sold trunks in the adjacent one-story annex. (Courtesy of MHPC.)

Communication by telephone in 1907 lay in the nimble fingers and quick wits of this assemblage of girls. Working on the second floor of Everett Kimball's Main Street store, these operators include, from left to right, the following: (front row) Laura Tracy and Henrietta Gilpatrick; (middle row) Katherine Foster, Eleanor Foster, Beatrice Foster, and Marion Smallidge; (back row) unidentified, Ruth Frazier, unidentified, Mary Gilpatrick, and Elsie Holmes. In 1913, the operators organized the Telephone Operators' Ball, creatively decorating the Neighborhood Hall with flowers, telephone instruments, and Central Office signs, under which 80 couples enjoyed dancing to Kelly's orchestra. (Courtesy of NEHL.)

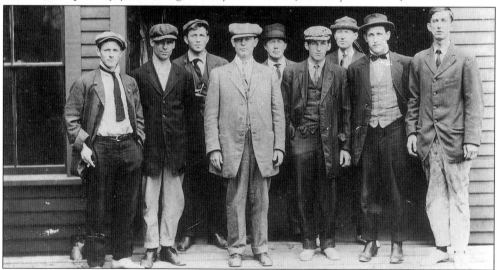

Northeast Harbor's building boom of the 1890s provided jobs for a variety of tradesmen, including Seldon R. Tracy, who opened his paint shop in 1893 beside Frost's blacksmith business. Less than a decade later, Tracy added an annex to his building to accommodate his growing business. The staff included, from left to right, Ray Foster, unidentified, George Fennelly, Seldon Tracy, Billy Manchester, unidentified, Charles Hardison, Samuel Tracy, and Bart Dyer. (Courtesy of NEHL.)

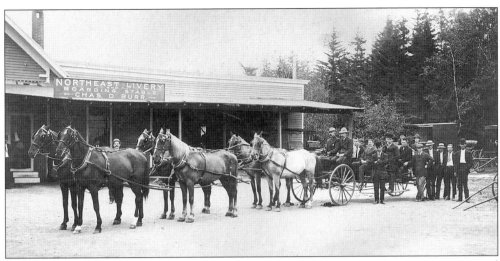

All that was needed for one to enjoy Mount Desert Island's magnificent scenery was a good team and a springy buckboard. Charles D. Burr's upscale livery could provide just the rig, as this photograph shows. Burr's entrance into the business was ushered by Ed Atwood of Brewer c. 1899. Soon, the partners had assembled 60 horses and employed 30 drivers and stable hands. Just after they built an elaborate stable on Corson Avenue in 1902, it burned, incurring a loss of $6,000. Burr continued in the business, renting runabouts, surries, and buckboards. (Courtesy of NEHL.)

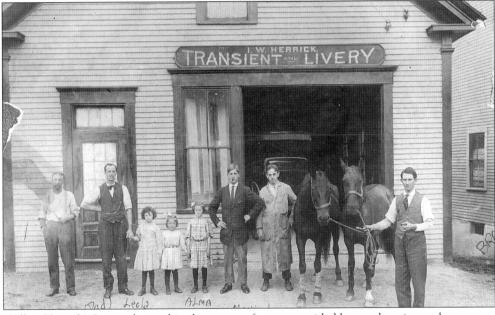

Wilbur Herrick's Livery, located in the center of town, provided horses, buggies, and wagons to islanders and transient tradesmen who needed temporary transportation. Shown from left to right are Wilbur Herrick; Walter Wagner; Wagner's four children, Leola, Geraldine, Alma, and Maynard; unidentified; and Oscar Ford. The roads in those early days were all dirt. In summer, they were dusty, in spring muddy. Between these seasons, ice haulers would pack down the roads with their sleighs of ice, making them hard on horses' hooves. Fortunately, blacksmith Frost's shop was right next door to the livery. (Courtesy of NEHL.)

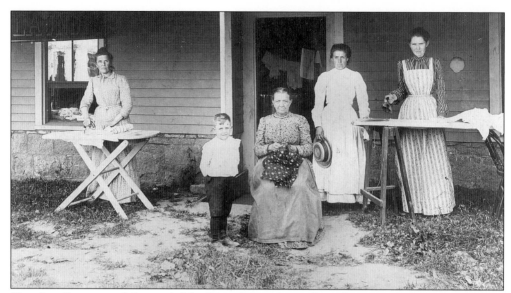

Grandma Sumner and the rest of the Herrick laundry staff are shown working on the starched white Victorian clothing, accented with the tucks, ruffles, and lace so popular at the time. As Emily Phillips recalls, "the clothes were scrubbed on the washboard, boiled in a large copper pot on the woodburning stove, and then hung out to dry, [with] the small flat pieces [spread] on the grass to whiten . . . Mother made her own soap and she used the old-fashion heavy irons with a separate wooden handle. There was nothing easy about it." These women would agree. (Emily Phillips Reynold, *Down Memory Lane*, page 52; courtesy of NEHL.)

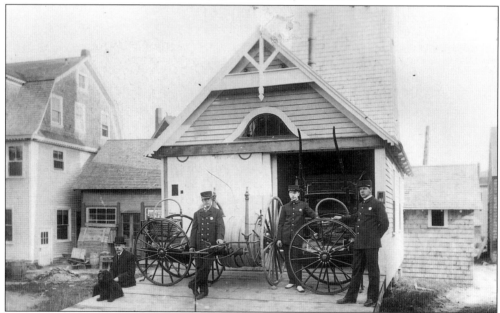

In response to Northeast Harbor's rapid growth in the 1890s, residents and summer people met in March 1898 to organize a community fire department and elected Bishop William C. Doane as its president. Five years later, the first firehouse was constructed opposite the Gilman School, a small building with a 40-foot hose tower topped by a bell. Here, uniformed firemen display hand-drawn pumping and hose equipment. (Courtesy of NEHL.)

In the early 1890s, summer resident Daniel Coit Gilman, president of Johns Hopkins University, led the effort to establish the Northeast Harbor Library. Herman L. Savage donated the land on South Shore Road, and his brother Fred drew a plan for a one-story, hip-roofed bungalow that housed a large reading room with a stone fireplace, a reference room, and a book room. This library served the community from 1892 until its replacement in 1950 by the present library, located across from the Union Church. (Courtesy of NEHL.)

The library organizers selected L. Belle Smallidge, the capable 21-year-old daughter of Asa and Phebe Smallidge, as its first librarian. Through this position, she established herself as an initiator. She graduated from Boston University in 1899 and founded the town's first real estate and insurance agency about two years later. With her husband, Jerome Knowles, a Bar Harbor lawyer, she expanded the Knowles Company into an establishment renowned for its integrity. (Courtesy of NEHL.)

Concerned that Northeast Harbor youths needed a place for wholesome and respectable amusements, Rev. Myles Henenway of St. Mary's-by-the-Sea proposed this two-story brick building with Tudor overtones, designed by the well-known Boston firm of Andrews, Jacques, & Rantoul. Opened in 1906, the hall offered activities for all ages: a winter library and reading room, a bowling alley, a kindergarten room, a pool room, and an auditorium used for plays and basketball games. (Courtesy of MHPC.)

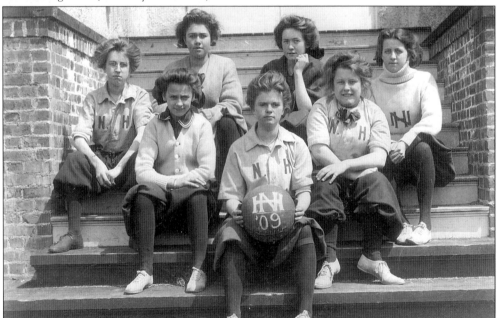

Only a few years after its opening, the Neighborhood House had the members of its girls' basketball team outfitted in uniforms. They are shown, from left to right, as follows: (front row) Henrietta Gilpatrick, Marion Smallidge, Eleanor Foster, and Katharine Foster; (back row) Elsie Holmes, unidentified, and Beatrice Foster. When these girls were not operating the switchboard, playing basketball, or rehearsing plays, they could probably be found dancing on the gym floor, ready to teach the boys a step or two. (Courtesy of NEHL.)

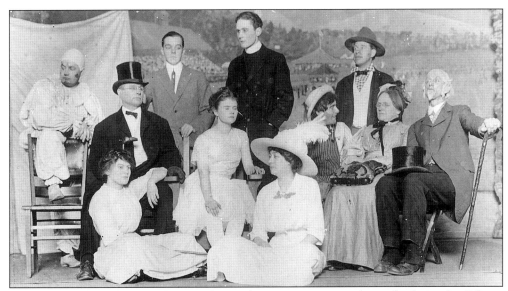

Although the play title is unknown, the production was organized as a fundraiser by Gilman High School's first graduating class. Parker Fennelly, standing at the center and one of the three members of the 1909 graduating class, received these first rave reviews of his acting: "Every part was well taken and Parker Fennelly, who took the part of a sturdy son of Erin's Isle, excelled, making many local hits that kept the audience convulsed." This debut began his long career in acting, first on radio, followed by Broadway plays, television, and movies. (BHR, April 23, 1909; courtesy of NEHL.)

Initially, the Northeast Harbor men's basketball team was loosely organized, gathering in the Parish House without a coach. A new gym at the Neighborhood House and the completion of a new high school were probably the impetus that helped them get organized. Posing in their uniforms are, from left to right, as follows: (front row) unidentified, Allie Reynolds, and Horace Reynolds; (back row) Edwin Tracy, Jackson Reynolds, George Manchester, and Ernest Ober. (Courtesy of NEHL.)

On this sunny day, five Victorian women clad in crisp white dresses row their round-bottomed boat to one of the outer islands offshore from Mount Desert. At night, one might find these women attending a dance at the Kimball House, dressed in white starched dresses adorned with bits of lace and their cheeks rouged and powdered. Now, however, their attention is on their plans for the island excursion: a walk along the beach, a picnic, and a bit of poetry before they return. (Courtesy of the Great Harbor Collection.)

Summertime in Northeast Harbor was synonymous with mountain hikes and it was a tradition to see how many mountain peaks one could mount each summer. This crew of young people, relaxing at Sargent Mountain's summit, could add yet another peak to their list. (Courtesy of the Great Harbor Collection.)

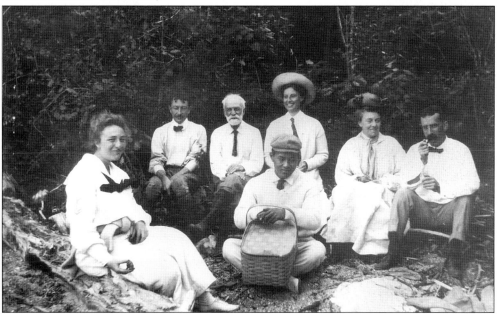

After a long hike over Western Mountain, James T. Gardiner (with the white beard) and his wife, Eliza (Doane), second from the right, relax for a picnic with their family and friends beside Long Pond. This is a typical excursion of the day. "Climbing expeditions became an important part of our social activities. Walks were combined with sails, row boat parties, and picnics, frequently all day and occasionally evening affairs, often involving camps that were maintained by friends . . . located on the westerly shores of Mount Desert Island. These camps were generally supervised by local farmers or fishermen, but all provisions had to be carried over . . . requiring real preparations." (Jarvis Cromwell, page 8; courtesy of NEHL.)

The daily routines for most children of the summer colony always included outside activities such as walks, swims, horseback riding, and jaunts in buggies or buckboards. In this case, the carriage is a small goat cart holding two small children, shaded from the bright sunlight with their summer hats. (Courtesy of the Great Harbor Collection.)

By the 1900s, the listing of Northeast Harbor cottagers and hotel guests resembled a Who's Who of academia and theology, as this gathering depicts. Shown from left to right are Rev. George P. Fisher, dean of Yale Divinity School, who stayed in Northeast with his son-in-law Dr. William Pepper, provost of the University of Pennsylvania; Andrew D. White, ambassador to Germany, probably staying at the Clifton House; and Johns Hopkins University Pres. Daniel Coit Gilman, who joined the cottage community in 1895 with Eliot's urging. Not all visitors chose to build cottages. Many rented houses annually, and some, such as Ambassador White, selected a comfortable hotel for his annual retreat. (Courtesy of Special Collections and Archives, Johns Hopkins University.)

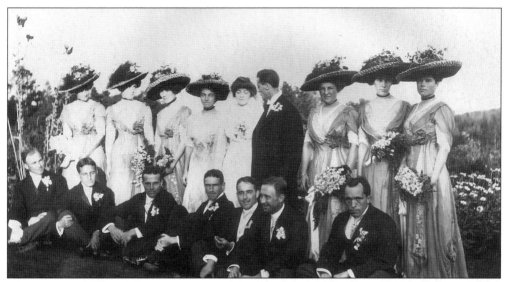

The wedding of Ann Terry Gardiner, granddaughter of Bishop William C. Doane, to Roy Pier of California was the major social event of the 1910 summer season, with more than 1,000 guests attending the reception. Even yachts moored in the harbor contributed to the celebration with cannon salutes. July and August were the busiest months for the social circuit and included garden parties, dances at the hotels, cotillions, and dinners, both simple and elaborate. Some families hosted dinners prior to the hotel dances. One flamboyant affair included "fourteen covers," meaning fourteen courses. (Courtesy of NEHL.)

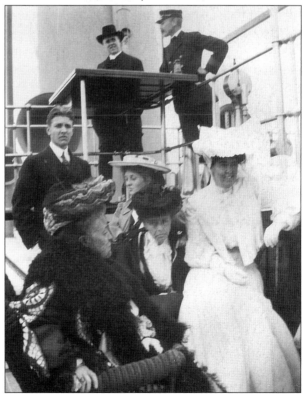

In 1904, for the first time in history, the archbishop of Canterbury, top center, visited the United States, attending the Episcopal General Convention in Boston. Part of his itinerary was this delightful cruise around Mount Desert Island on J. Pierpont Morgan's steam yacht *Corsair*. They stopped at Northeast Harbor, where the archbishop delighted parishioners at St. Mary's-by-the-Sea with a sermon and marked the occasion by planting a tree on the church grounds. Afterward, he enjoyed the view from the upper deck of the *Corsair* as he sailed around the island joined by the Doane, Gardiner, and Huntington families. (Courtesy of NEHL.)

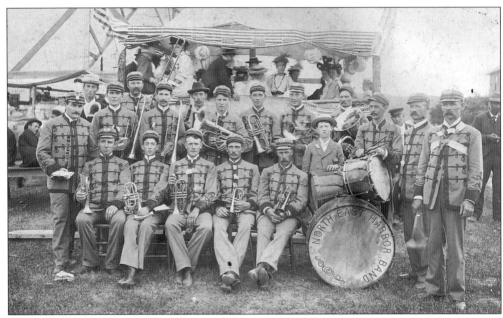

For this 1898 Fourth of July celebration, the Northeast Harbor Brass Band provided festive accompaniment for patriotic speeches. Architect Fred L. Savage, left, led his 14 fellow islanders, all dressed in their smart uniforms, in this endeavor. Back in 1892, the band had begun as a winter club instructed by Frank Whitmore of Bar Harbor. Although their time was short and funds were lacking, the members pulled together for special occasions. Starting in 1904, with financial support from the summer community, the band began offering regular open-air concerts on a stage built for that purpose. (Courtesy of Rick Savage.)

Coastal swimming in Northeast Harbor was restricted to hardy souls capable of withstanding Maine's chilly 60-degree water. In 1898, the summer people of Northeast Harbor, concerned that local conditions prevented their children from learning this important skill, built a retaining wall in a local cove to create a pool of water that was warmed. These young ladies, dressed in their swimming finery of dark cotton blouses, skirts, and stockings, are thrilled with the prospect of 72-degree water. This area had been the site, decades earlier, of baptisms. (Courtesy of the Great Harbor Collection.)

An integral part of summer entertainment were *tableaux vivant* (literary enactments), often organized as fundraisers. Islander Billie Favour fondly remembers the vaudeville shows produced annually to benefit the neighborhood house. A local dressmaker would spend most of the summer costuming the cast. For the play shown here, *Universal Neurosthemia*, written by summer resident Margaret Gardiner, the dramatis personae dressed simply in garden party attire. More than 200 guests attended the play, held on Ye Haven's lawn *c.* 1904. (Courtesy of NEHL.)

Northeast Harbor's swimming pool offered no shortage of merriment to its members. Here, two jovial clowns demonstrate their balancing skills. Even the annual aquatics sports competition included a few amusing features. The "tancy relay races" required that each partner had either their arms or legs tied together and, upon reaching the other side, had to eat blueberry pie. The other partner would then swim back with legs tied, balancing an egg on their stomach. Credit for the creation of these fun races lies with Dr. Harrison, the pool's long-term instructor, known for his unfailing good humor. (Courtesy of the Great Harbor Collection)

Laughter and watermelons were key to this summer outing along the sound. Although these youths were busy working for hotels, the telephone switchboard, the paint shop, or other seasonal opportunities, they still made time for picnics, hikes, and sails. Their excursions, however, were more spontaneous than those of the summer colony, as that was all their time could afford. (Courtesy of the Burr family.)

These permanent residents have borrowed their mother's coats and hats, all of the latest fashionable styles, for an impromptu theatrical. The character at the left, fearing recognition, has opted for an incognito look. Big kids had their favorite pastimes, and so did the youngsters. Billie Favour remembers the thrill of climbing the rooftops of the four-story Rock End Hotel with her friends, an event they commonly referred to as climbing their Everest. While these pastimes amused the children, they were met with disapproving eyes from their families. (Courtesy of the Burr family.)

Locally, President Gilman's classic quip is still remembered: "The cockpit of a boat is as good a place for conversation as around a dinner table." It is no surprise, then, to find the Gardiner family entertaining British ambassador James Bryce and his wife aboard the yacht *Kiawa* c. 1909. While Captain Hadlock manned the helm, the guests could discuss worldly topics surrounded by fresh air and picturesque scenery. (Courtesy of NEHL.)

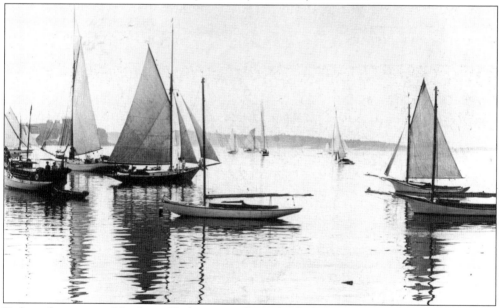

Early yacht racing in Northeast Harbor generally evolved when two boats met. One would trim the sails just a bit, while the other would surreptitiously try a better set. These informal competitions began in cat boats and Friendship sloops. The lack of standards for boats created an unfair advantage for those with faster crafts. In 1912, this changed with the introduction of the first 17-foot class boats. These A boats were identical, gaff-rigged sloops designed for competition, and moderately priced at about $600 to $800. Not long after, the B boat was introduced and, in 1923, just prior to this 1925 photograph, the Northeast Harbor Fleet was organized with the A boat as its primary boat. (Courtesy of Sturgis Haskins.)

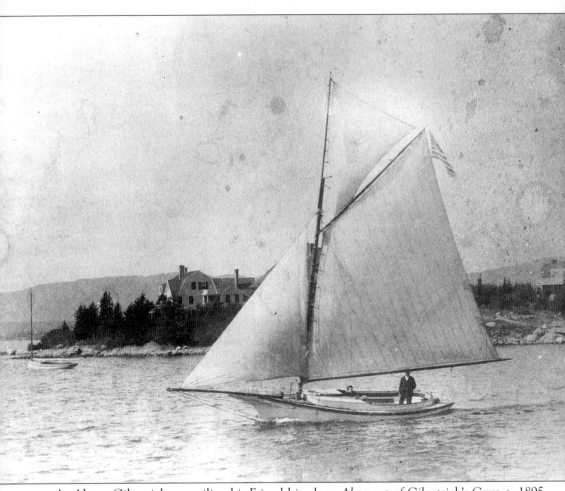

As Abram Gilpatrick was sailing his Friendship sloop *Alma* out of Gilpatrick's Cove *c.* 1895, much was changing for the permanent residents of Northeast Harbor. Tourism jobs were replacing livelihoods based on fishing, coasting, and farming. What had not changed was the natural ability of these hardworking natives to adapt to changing conditions. Abram Gilpatrick exemplifies this trend perfectly. In winter, he would fish and collect lobsters in the *Alma*. After 1910, he also ran a dairy and delivered milk year-round. In the summer, the *Alma* would be cleaned up and painted to take rusticators out on excursions, its wide open cockpit comfortable for a large party of sojourners. He also ran the livery off the Rock End Dock and taught children to sail, passing on years of experience to young minds. Samuel E. Morrison reminiscences, "Abe was beloved by all the small boys of the summer colony, to whom he was kindly, helpful, and indulgent, keeping a box of clams at his dock so that they could fish for flounders." Although Abe passed away in 1941, his skills as a mariner live on in successive generations of sailors. (Courtesy of NEHL.)